WATSON-GUPTILL
PUBLICATIONS/
NEW YORK

HOW TO DRAW
KNIGHTS, KINGS, QUEENS & DRAGONS

CHRISTOPHER HART

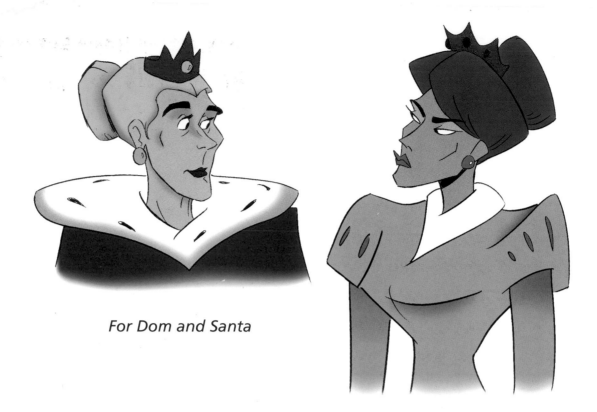

For Dom and Santa

Senior Editor: Candace Raney
Project Editor: Alisa Palazzo
Designer: Bob Fillie, Graphiti Design, Inc.
Production Manager: Ellen Greene

Front and back cover illustrations by Christopher Hart
Text and illustrations copyright © 1999 Christopher Hart

First published in 1999 by Watson-Guptill Publications,
a division of BPI Communications, Inc.,
1515 Broadway, New York, N.Y. 10036

Library of Congress Cataloging-in-Publication Data
Hart, Christopher.
 How to draw knights, kings, queens & dragons / Christopher Hart.
 p. cm.
 Includes index.
 ISBN 0-8230-2378-8 (pbk.)
 1. Knights and knighthood in art. 2. Kings and rulers in art. 3. Civilization,
Medieval, in art. 4. Drawing—Technique. I. Title.
 NC825.K54H37 1999
 743'.8—dc21 99-19353
 CIP

Printed in Singapore

First printing, 1999

1 2 3 4 5 6 7 8 / 06 05 04 03 02 01 00 99

CONTENTS

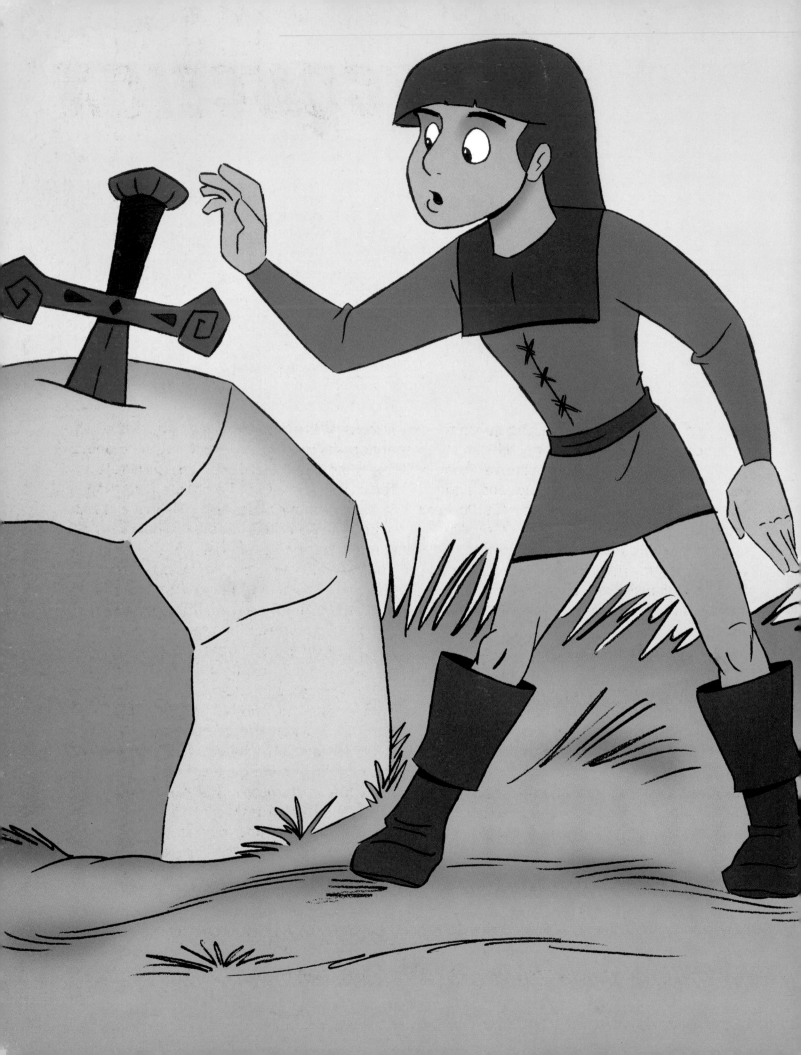

INTRODUCTION

If there is a more enduring genre for comic strips, animation, children's storybooks, and graphic novels than that of knights, kings, queens, and dragons, I am not aware of it. Popular characters such as King Arthur, his loyal subjects, and his arch enemies inhabited a world of magic and wonder, courage and chivalry, romanticism and betrayal. No other area of illustration can so easily evoke strong emotions.

This book includes complete step-by-step instructions on how to draw all the favorite figures, such as King Arthur and the wizard Merlin, along with all sorts of other kings, queens, knights, princes, princesses, squires, villagers, and awesome dragons. Artistic license allows for some creativity when designing costumes, armor, and weaponry for these characters. You don't always have to be historically accurate and literal. However, I have researched the armor of knights and their noble steeds at various castles in England, as well as at The Metropolitan Museum of Art in New York City, so these interpretations are rooted in fact.

By following the step-by-step instructions in this book, you'll learn many important lessons of life drawing—techniques that all animators must know—without even being aware of it. I'll introduce these principles in the dynamic poses of knights, rather than in the academic poses featured in standard figure model books. Medieval characters come in a range of shapes and sizes. Typical knights generally have heroic proportions, but there are also young knights (squires) and older knights, each with their own particular body types. Kings can be rotund and robust or skinny and frail. Princesses are always beautiful, while queens can tend toward the stodgy and snooty. Sorcerers are always tall, frail, and old. In this way, you'll learn to draw a variety of body types not generally available to art students in even the best life-drawing classes.

Pestilence, famine, and religious oppression aside, the Dark Ages weren't all dark. There were many lively and jovial characters living behind the castle walls. If you enjoy the adventures of those hearty souls who lived for battle and the fair hand of a maiden, then I invite you to join me for a visit back in time to a more noble age. So turn the page, have a joust, and enter the wondrous world of knights, kings, queens, and dragons.

KNIGHTS

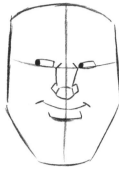

Of all the medieval characters, knights are perhaps the most popular. In many stories, the survival of the kingdom rested on the success or failure of a single brave knight.

A rugged male character has a wide jaw and a powerful chin. The forehead is on the small side.

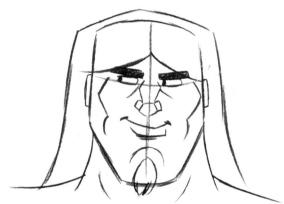

The eyes rest on the horizontal guideline. The bridge of the nose falls where the horizontal and vertical guidelines intersect. Note the angles of the nose; they give a rugged look to the face.

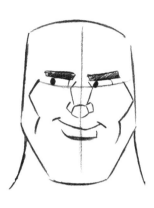

Give him heavy eyebrows. Remember, eyebrows are muscles, and all of this guy's muscles are thick. Also, define the cheekbones, which travel down the face and become expression lines or "mouth creases."

The hairstyle and type of beard should be typical of medieval times.

Rugged Knight

To learn to draw the head, start with a basic, rugged knight. You can then use these same principles to draw the head for any character. Start with the front view. Note the style of the hair and goatee, which places the knight in or before the 1400s timewise.

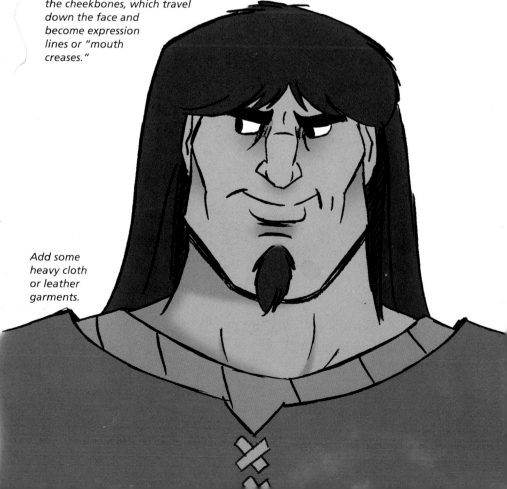

Add some heavy cloth or leather garments.

The Knight's Profile

The side view on a rugged character must clearly show the sharp angles of all parts of the face—the forehead, bridge of the nose, nose, upper and lower lips, and chin—as if they were chiseled in stone. Surprisingly, the *angles* of the face are more important than the inner features in creating a rugged look.

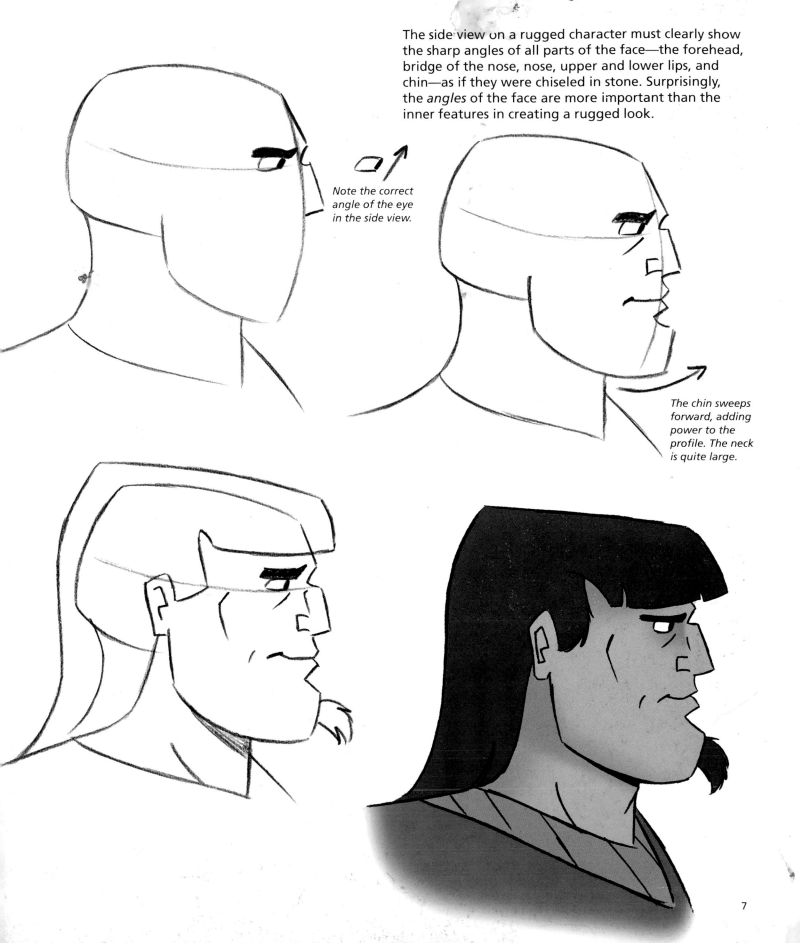

Note the correct angle of the eye in the side view.

The chin sweeps forward, adding power to the profile. The neck is quite large.

Other Head Angles

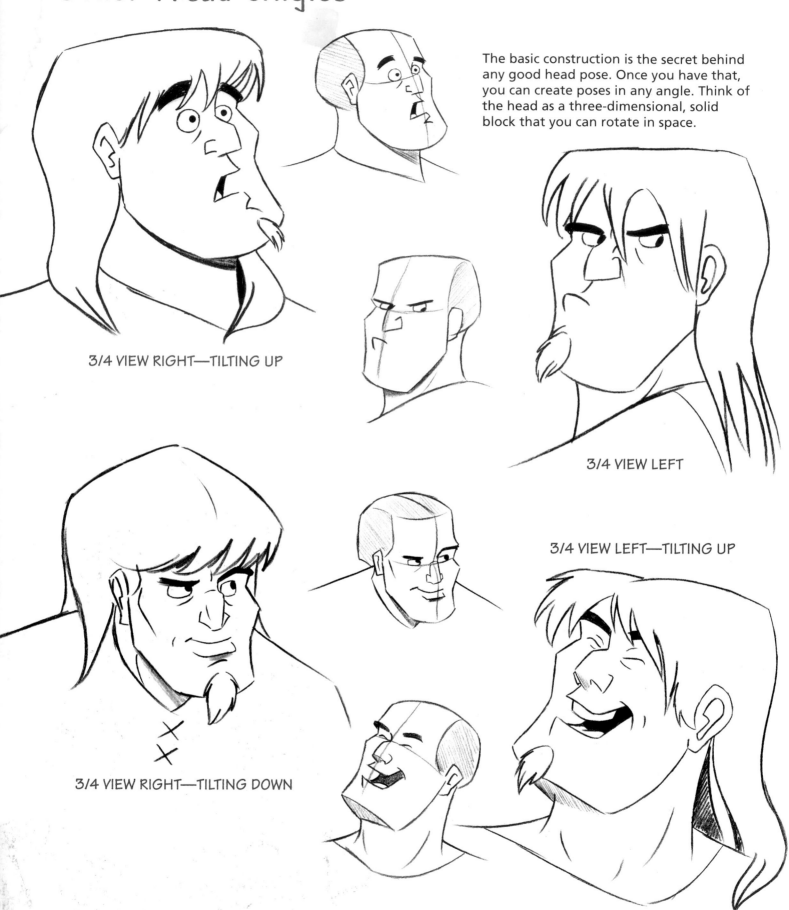

The basic construction is the secret behind any good head pose. Once you have that, you can create poses in any angle. Think of the head as a three-dimensional, solid block that you can rotate in space.

3/4 VIEW RIGHT—TILTING UP

3/4 VIEW LEFT

3/4 VIEW LEFT—TILTING UP

3/4 VIEW RIGHT—TILTING DOWN

In the era of knights, life spans were much shorter than they are today; few people lived past the age of 40. Therefore, you had plenty of knights who were practically teenagers. To create a youthful appearance, give your knight bright eyes, an upturned nose, and a sleek chin; limit the amount of facial expression lines; keep the character clean cut; and add long hair.

9

Basic Knight Body

I've devised a simplified method for drawing the body: Break down the figure into its major masses so that you can assemble it without having to labor over the skeleton and the hundreds (520 to be precise) of individual muscles.

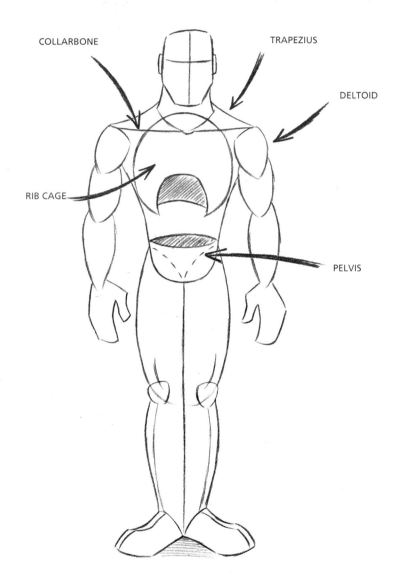

COLLARBONE

TRAPEZIUS

DELTOID

RIB CAGE

PELVIS

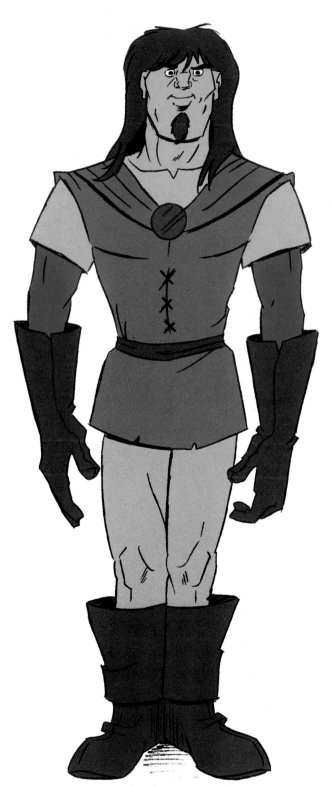

The trapezius muscle connects the shoulders to the neck; it's powerful and pronounced on strong people but is almost nonexistent on weak and skinny characters.

The deltoid is a teardrop-shaped shoulder muscle that wedges into the upper arm between the biceps and triceps.

The collarbone is a "shelf" onto which the chest muscles attach. It's a fairly straight line that runs across the top of the chest. When tilted it shows which way a character is leaning.

Note the hollowed-out, shaded area of the rib cage, which is where the abdominal muscles go.

The pelvic area is small on athletic types, big on portly types.

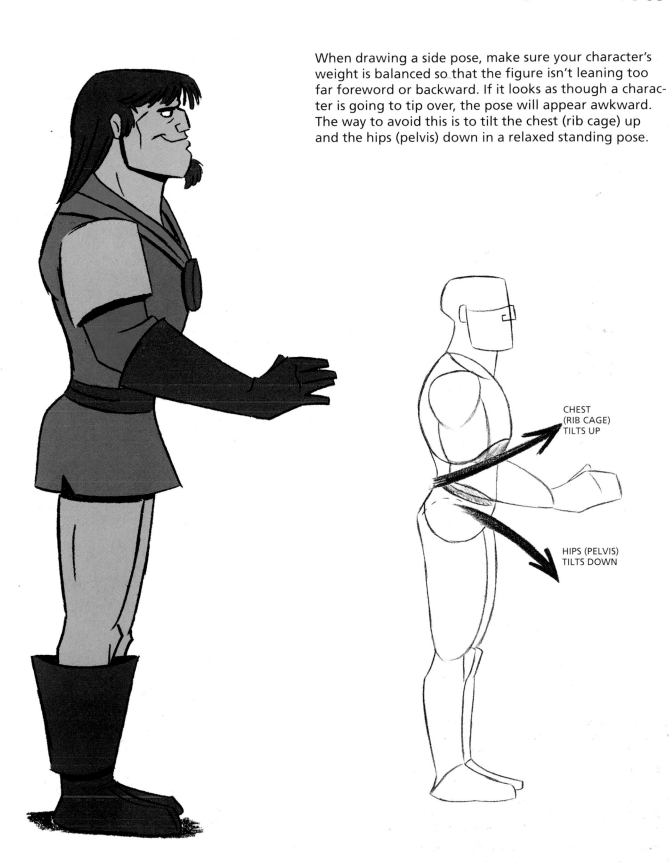

When drawing a side pose, make sure your character's weight is balanced so that the figure isn't leaning too far foreword or backward. If it looks as though a character is going to tip over, the pose will appear awkward. The way to avoid this is to tilt the chest (rib cage) up and the hips (pelvis) down in a relaxed standing pose.

CHEST
(RIB CAGE)
TILTS UP

HIPS (PELVIS)
TILTS DOWN

Simplified Body Constructions

Using the basic body construction just explained, you can develop simplified body constructions for all sorts of characters. Pay careful attention to the rib cage and pelvis areas. Note that large characters have large rib cages, while thin characters have narrow ones.

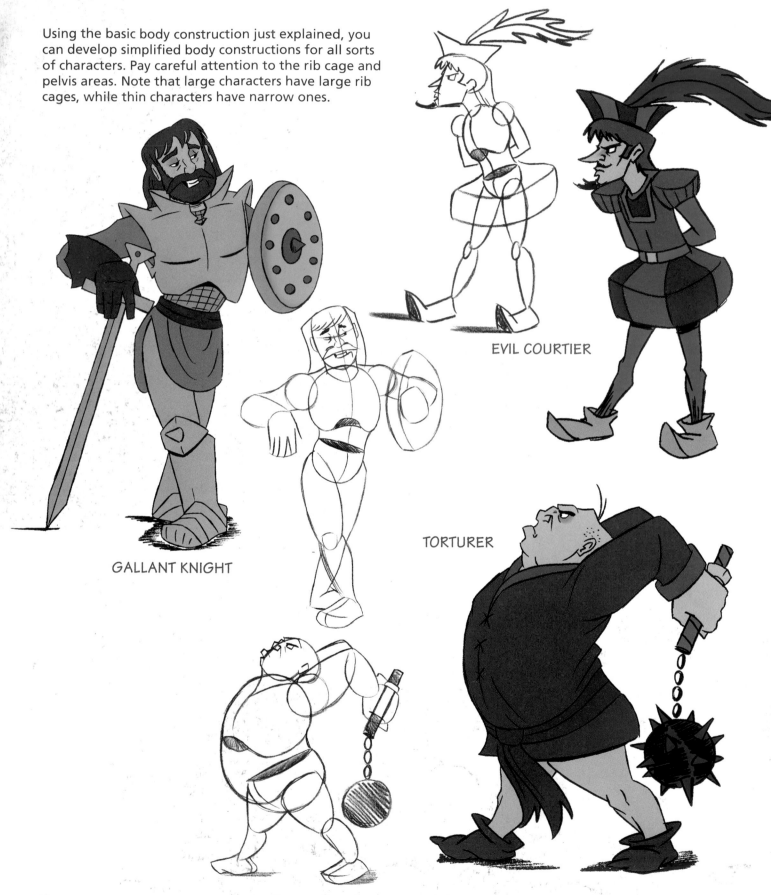

EVIL COURTIER

GALLANT KNIGHT

TORTURER

FAIR MAIDEN

SAD KNIGHT

Stress Points

To create effective poses for knights or any other characters, pinpoint specific areas of the body that flex and show tension. These *stress points* will vary with each pose. The arrows indicate these points on a few different characters.

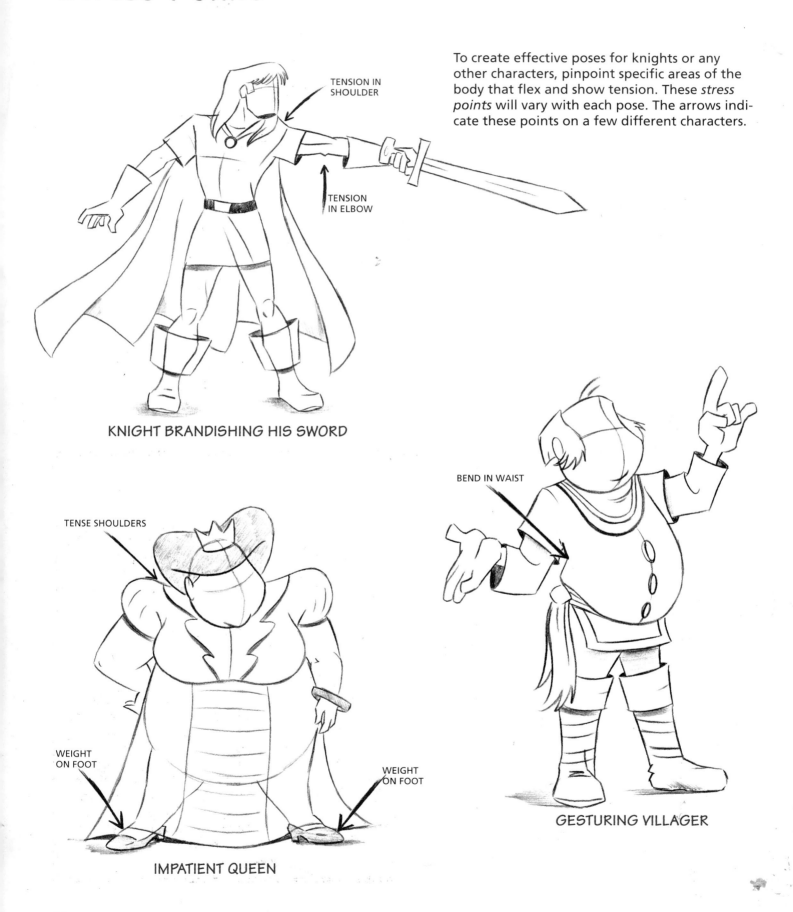

TENSION IN SHOULDER

TENSION IN ELBOW

KNIGHT BRANDISHING HIS SWORD

TENSE SHOULDERS

WEIGHT ON FOOT

WEIGHT ON FOOT

IMPATIENT QUEEN

BEND IN WAIST

GESTURING VILLAGER

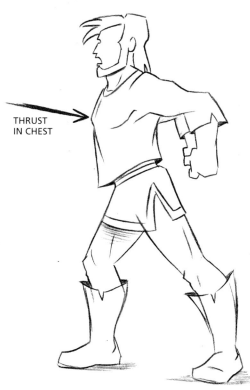

THRUST
IN CHEST

KNIGHT READY FOR BATTLE

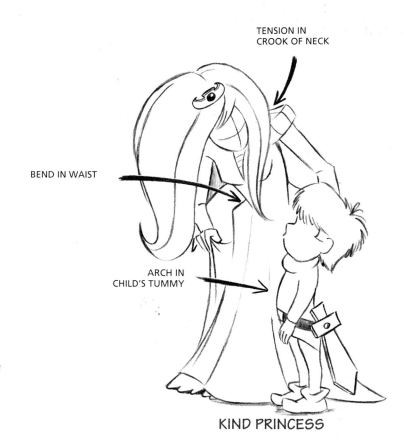

TENSION IN
CROOK OF NECK

BEND IN WAIST

ARCH IN
CHILD'S TUMMY

KIND PRINCESS

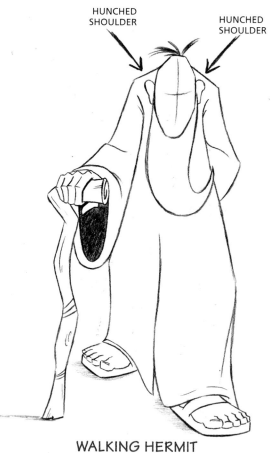

HUNCHED
SHOULDER

HUNCHED
SHOULDER

WALKING HERMIT

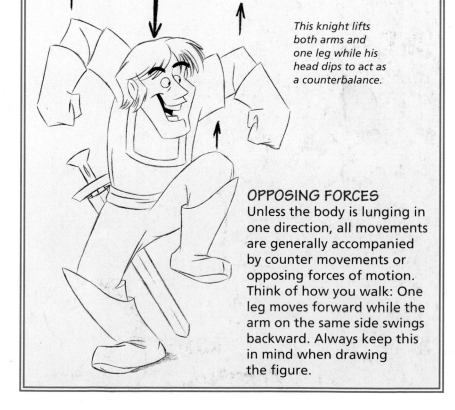

This knight lifts both arms and one leg while his head dips to act as a counterbalance.

OPPOSING FORCES

Unless the body is lunging in one direction, all movements are generally accompanied by counter movements or opposing forces of motion. Think of how you walk: One leg moves forward while the arm on the same side swings backward. Always keep this in mind when drawing the figure.

Medieval Body Types

Characters from the medieval period had clearly identifiable roles—king, knight, princess, squire, and so on. When you invent a character, caricature not just the face but the body, as well. This will help to better convey a character's role or profession.

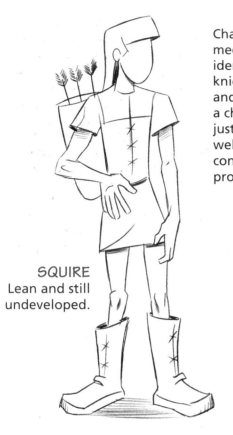

SQUIRE
Lean and still undeveloped.

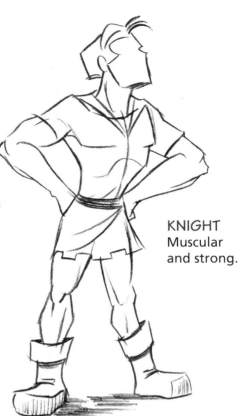

KNIGHT
Muscular and strong.

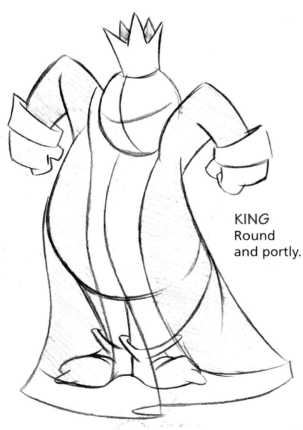

KING
Round and portly.

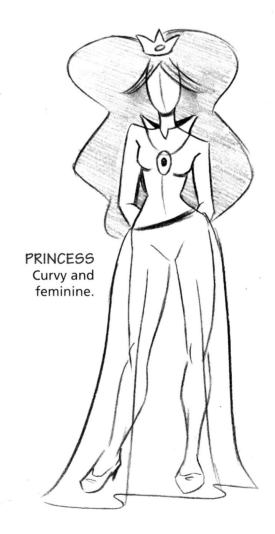

PRINCESS
Curvy and feminine.

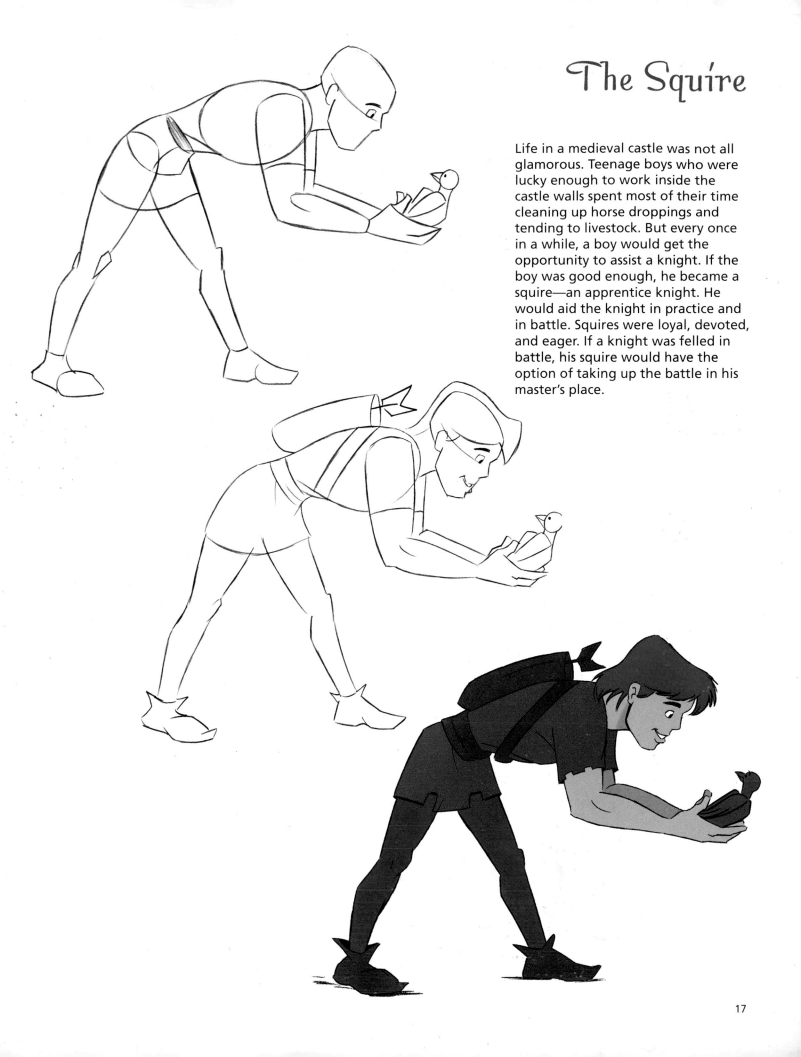

The Squire

Life in a medieval castle was not all glamorous. Teenage boys who were lucky enough to work inside the castle walls spent most of their time cleaning up horse droppings and tending to livestock. But every once in a while, a boy would get the opportunity to assist a knight. If the boy was good enough, he became a squire—an apprentice knight. He would aid the knight in practice and in battle. Squires were loyal, devoted, and eager. If a knight was felled in battle, his squire would have the option of taking up the battle in his master's place.

Funny Knights

Have fun with your characters. Not all knights are designed to win the princess' heart, nor should they be. Every storybook, comic strip, and animated film requires supporting players and comic sidekicks.

Knight-and-Squire Comedy Team

A knight-and-squire comedy team is a natural, because of the inherent physical differences between the two characters. One is big and the other is small—which is the case in most successful comedy teams. You could even play them as a father/son pair.

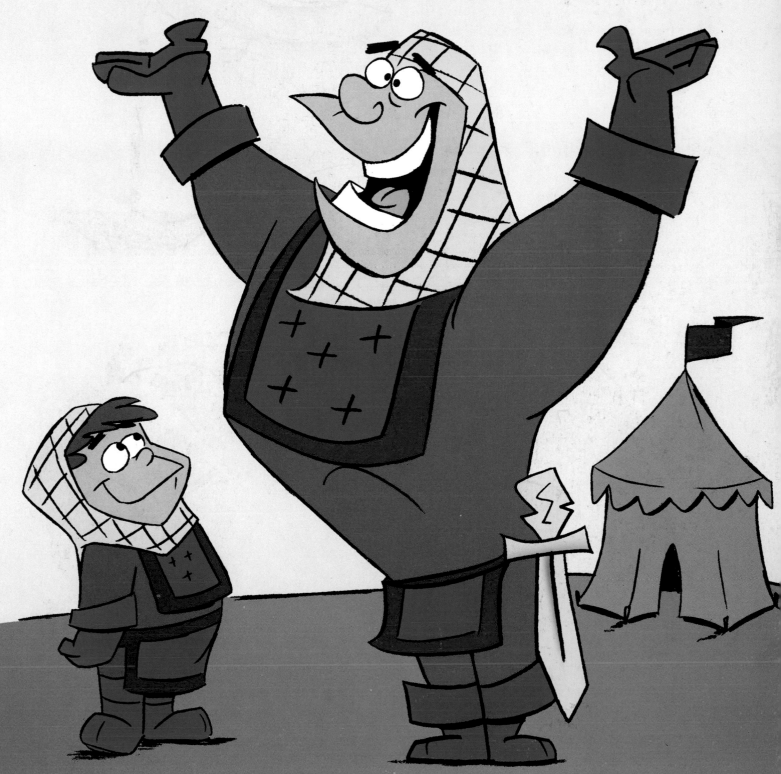

ARMOR

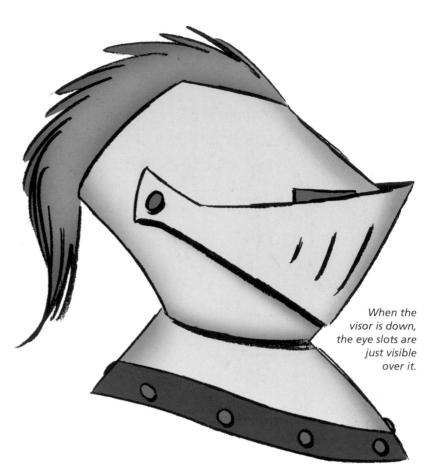

The important thing to remember when drawing knights in armor is that armor is very heavy and cumbersome. Therefore, the movements of a knight wearing armor are slow and limited in range. Armor is not formfitting but big and bulky.

When the visor is down, the eye slots are just visible over it.

The Helmet

The helmet for a suit of armor rests on a metal shoulder piece or platform. The visor or faceplate is usually moveable. Eye slots are built into the visor or are just above it. Note that although function was the most important consideration in the construction of all armor, decoration and artistry were also factors in the design.

When the visor is raised, the eye slots disappear.

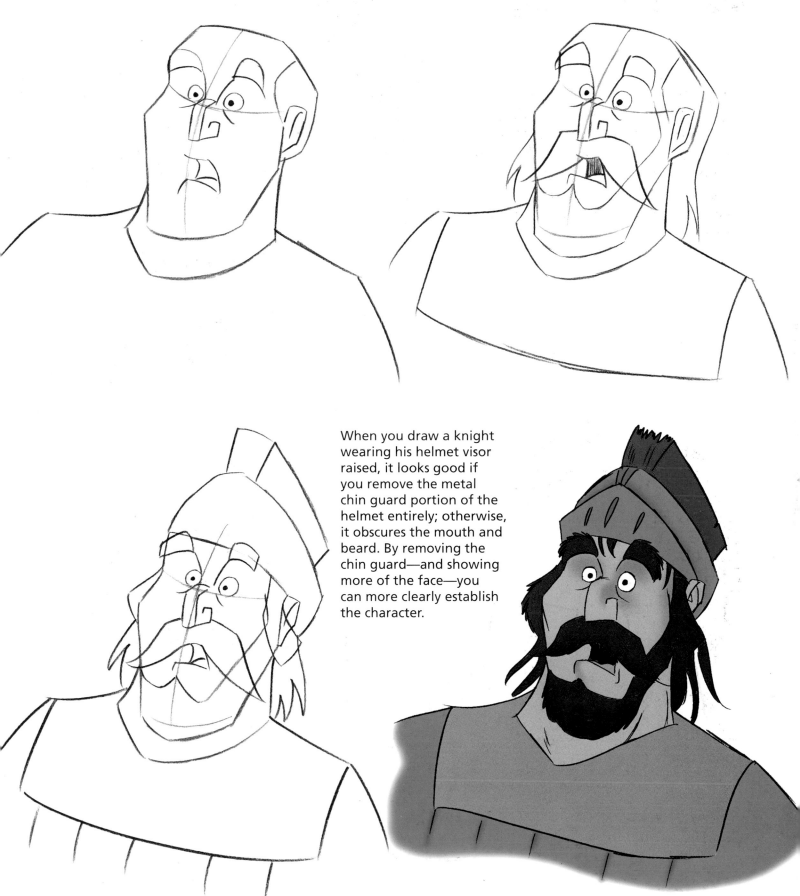

When you draw a knight wearing his helmet visor raised, it looks good if you remove the metal chin guard portion of the helmet entirely; otherwise, it obscures the mouth and beard. By removing the chin guard—and showing more of the face—you can more clearly establish the character.

Types of Helmets

These are the basic styles for actual helmets used by knights in battle. You can, of course, take artistic liberties and alter them. Although there are many varieties of helmets, it's helpful to start with one of these four basic types and expand from there.

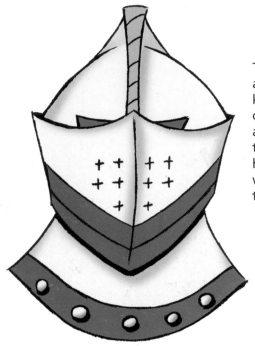

AXE STYLE

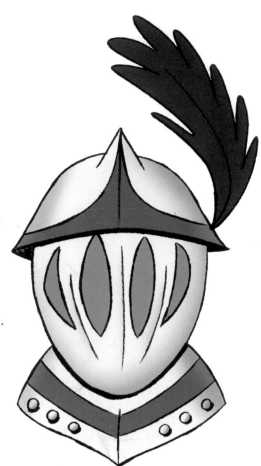

TOTAL FACE SHIELD

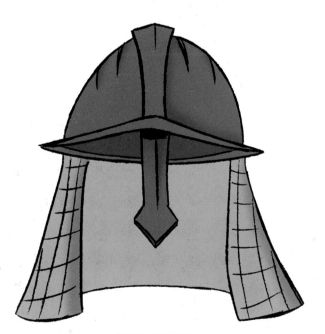

NOSE GUARD

Note the mail around the neck with this style of helmet. Mail is armor made of metal links or rings. It hung like a garment around the neck, shoulders, and other parts of a suit of armor. Also called chain mail, it allowed for better movement of the body, whereas plate armor was stiffer and accommodated less bending.

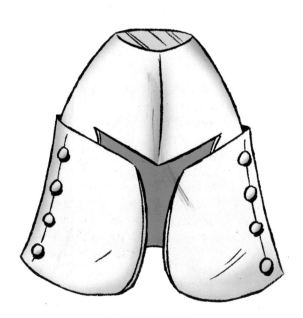

BUCKET STYLE

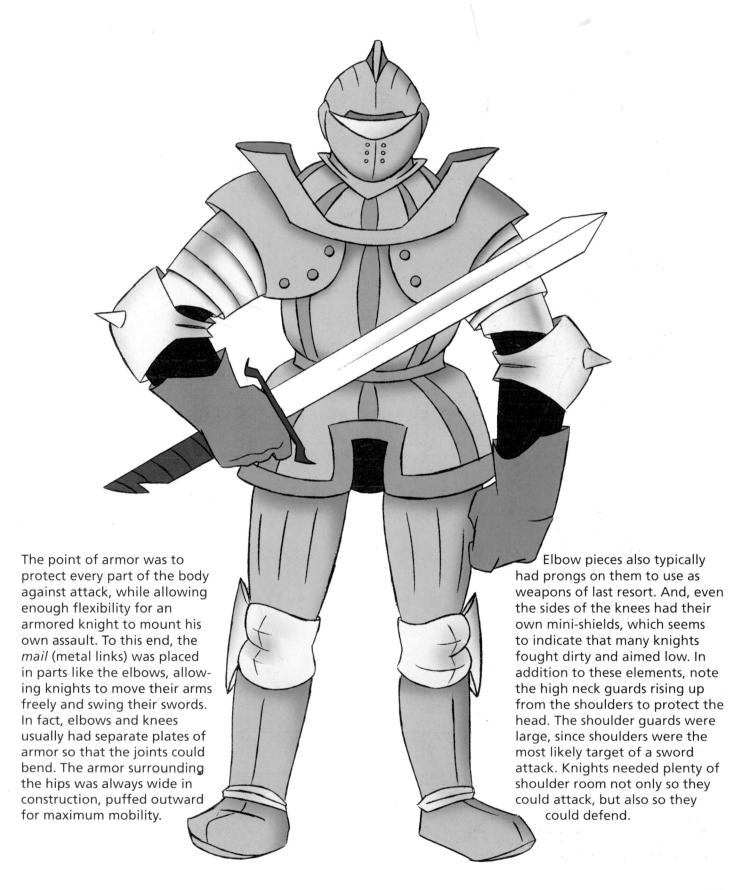

The point of armor was to protect every part of the body against attack, while allowing enough flexibility for an armored knight to mount his own assault. To this end, the *mail* (metal links) was placed in parts like the elbows, allowing knights to move their arms freely and swing their swords. In fact, elbows and knees usually had separate plates of armor so that the joints could bend. The armor surrounding the hips was always wide in construction, puffed outward for maximum mobility.

Elbow pieces also typically had prongs on them to use as weapons of last resort. And, even the sides of the knees had their own mini-shields, which seems to indicate that many knights fought dirty and aimed low. In addition to these elements, note the high neck guards rising up from the shoulders to protect the head. The shoulder guards were large, since shoulders were the most likely target of a sword attack. Knights needed plenty of shoulder room not only so they could attack, but also so they could defend.

Simplified Armor

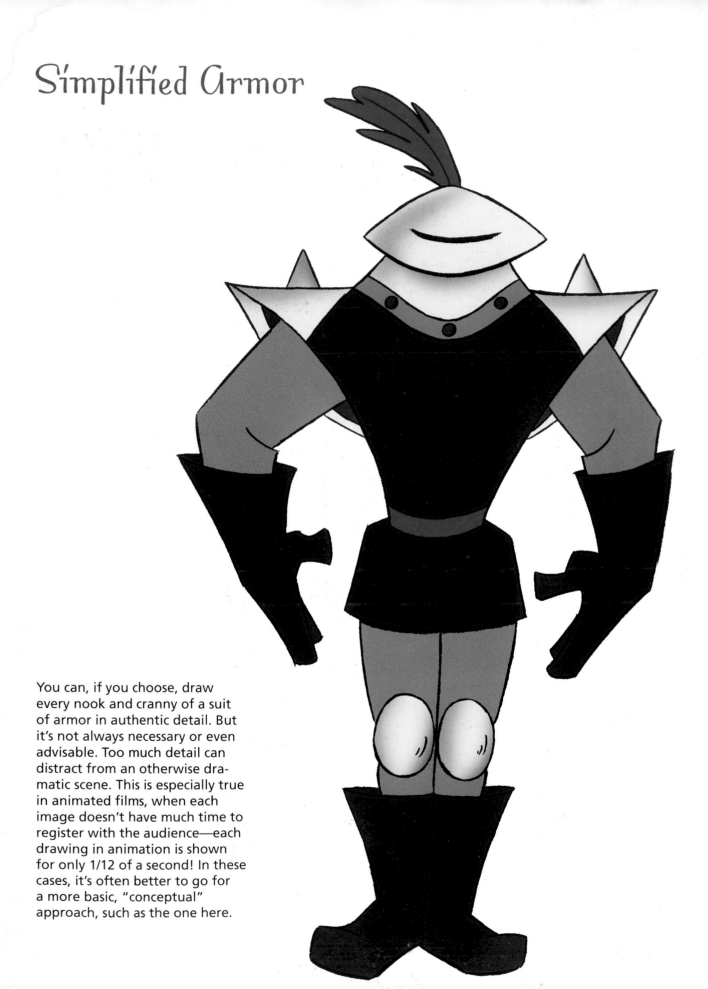

You can, if you choose, draw every nook and cranny of a suit of armor in authentic detail. But it's not always necessary or even advisable. Too much detail can distract from an otherwise dramatic scene. This is especially true in animated films, when each image doesn't have much time to register with the audience—each drawing in animation is shown for only 1/12 of a second! In these cases, it's often better to go for a more basic, "conceptual" approach, such as the one here.

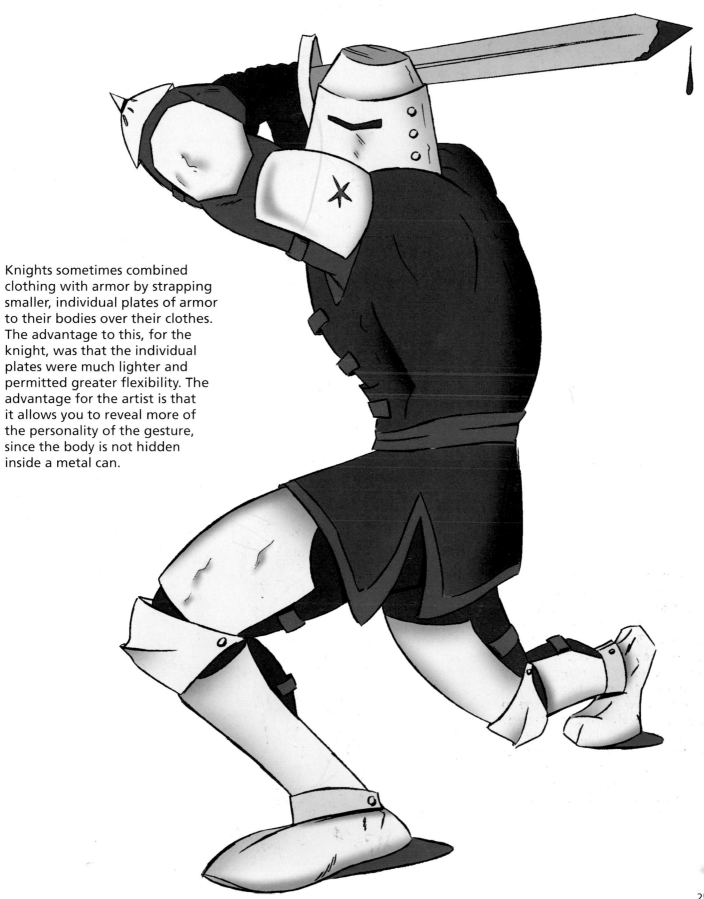

Armor Plates

Knights sometimes combined clothing with armor by strapping smaller, individual plates of armor to their bodies over their clothes. The advantage to this, for the knight, was that the individual plates were much lighter and permitted greater flexibility. The advantage for the artist is that it allows you to reveal more of the personality of the gesture, since the body is not hidden inside a metal can.

Swords and Spears

Many people believe that swords are made up of a separate blade and handle. This is not so. The handle is an *extension* of the blade.

The blade continues all the way down and forms the handle of the sword.

The handle is wrapped in cloth or leather and a hand guard is then affixed.

This is a typical—but incorrect—version of the sword: The handle is too short.

This is the sword as many beginners draw it—with the blade wider than the handle. Avoid this version; there is no such sword.

This is the correct sword—with a handle long enough for two hands, side by side, to grasp it. Remember, a sword is a heavy piece of metal; it took the strength of two arms to wield it properly.

EXCALIBUR

According to legend, Excalibur was a sword from the Other World lent to King Arthur by the Lady of the Lake. Its sheath was said to have magic properties that protected the wearer from losing blood. In fact, the sword's power was thought so great that possession of it could ensure victory over the enemy. When Arthur lay dying without a direct heir, and no one was deemed competent to handle Excalibur, Arthur ordered Bedivere (the last surviving knight) to throw the sword back into the lake—into the hand of the Lady of the Lake, who rose up out of the water to catch it.

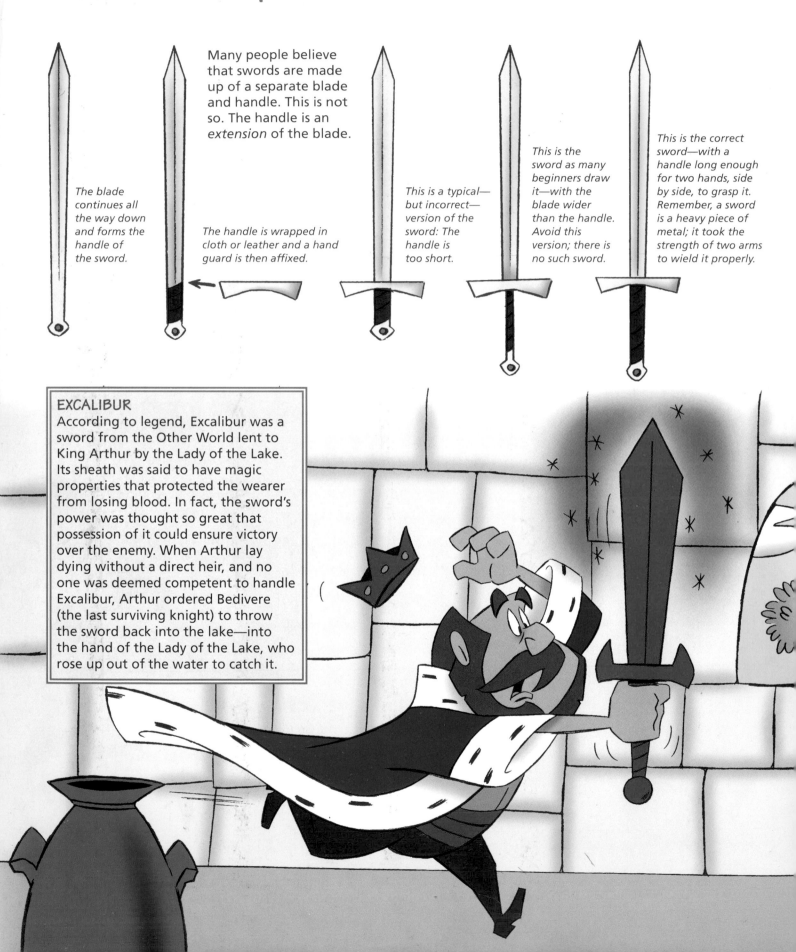

Spears were used both in hunting and in battle. Some also doubled as axes. The long handle is wooden, while the blade is metal. Here are a few examples.

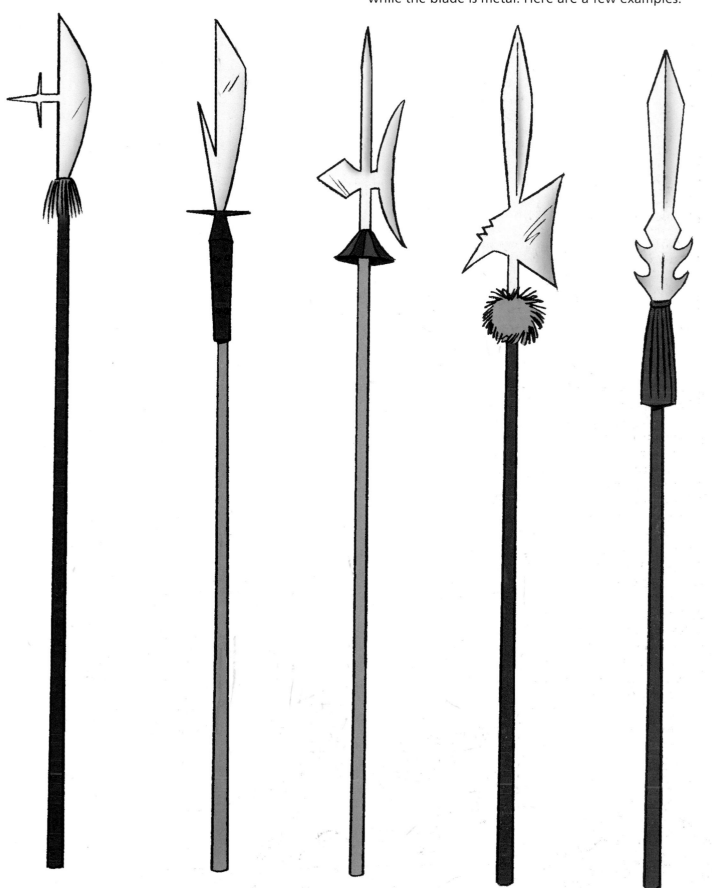

Capes and Jackets

There may not have been a Gap or Banana Republic in medieval days, but that doesn't mean knights weren't fashion conscious. Actually, all these robes and heavy garments were not strictly for ornamental purposes. Castles were very cold. Fireplaces were the only source of heat in these stone buildings, and warm garments were a necessity. Garments could be worn alone or in combination with armor.

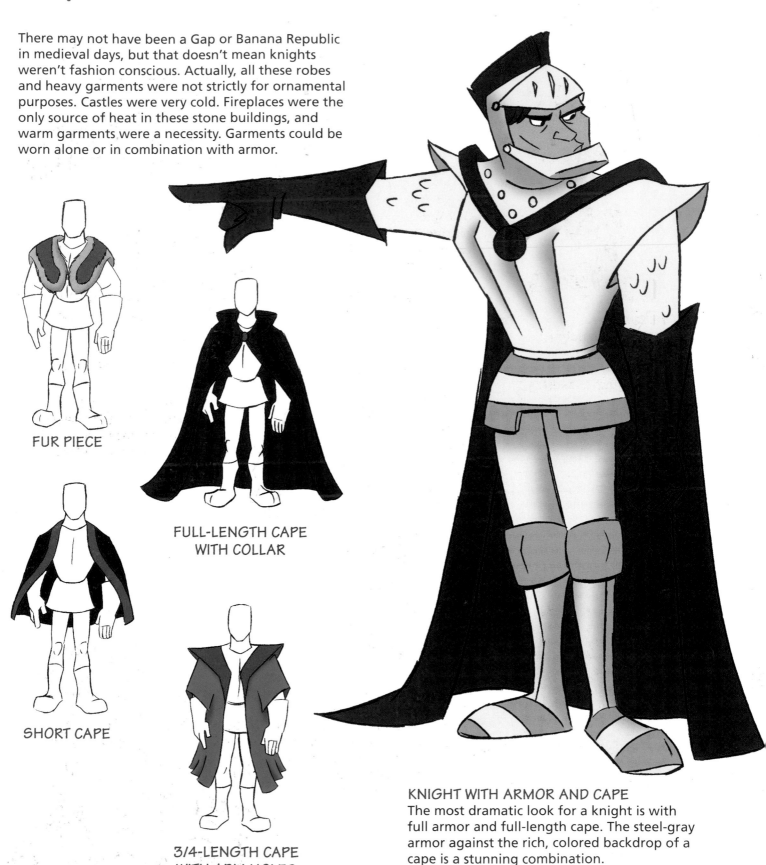

FUR PIECE

FULL-LENGTH CAPE
WITH COLLAR

SHORT CAPE

3/4-LENGTH CAPE
WITH ARM HOLES

KNIGHT WITH ARMOR AND CAPE
The most dramatic look for a knight is with full armor and full-length cape. The steel-gray armor against the rich, colored backdrop of a cape is a stunning combination.

Funny Armored Knights

Since armor is so big and clunky, you can exaggerate it to great comic effect. These are a few cartoony variations of some less-than-noble knights.

SMART ALECK
With a big nose protruding from the helmet, you don't even need to see the eyes to know that this guy's a jokester.

BRAWNY
Making the shoulders extremely wide and the legs very short, creates an intimidating character. This knight's head is relatively small, making his body look larger by comparison.

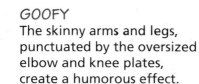

GOOFY
The skinny arms and legs, punctuated by the oversized elbow and knee plates, create a humorous effect.

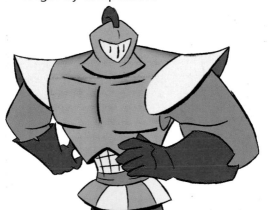

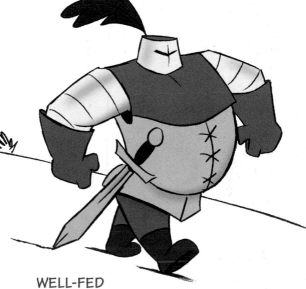

POWDER KEG
He's short and hot tempered but not the least bit threatening. This knight's oversized sword, cape, and helmet make him look like he's trying on his dad's clothes.

WELL-FED
Pity the poor horse that this guy saddles up. Note that his stomach hangs over his belt line.

Armored Horses

Attacking a knight's horse was the medieval equivalent of shooting at the tires of a getaway car. Therefore, knights had to protect their mode of transportation. Only the upper body of the horse was outfitted with armor—never the forelegs or hind legs. The hood over the horse's neck was typically made of mail. Note the extra bump at the back to allow room for the tail.

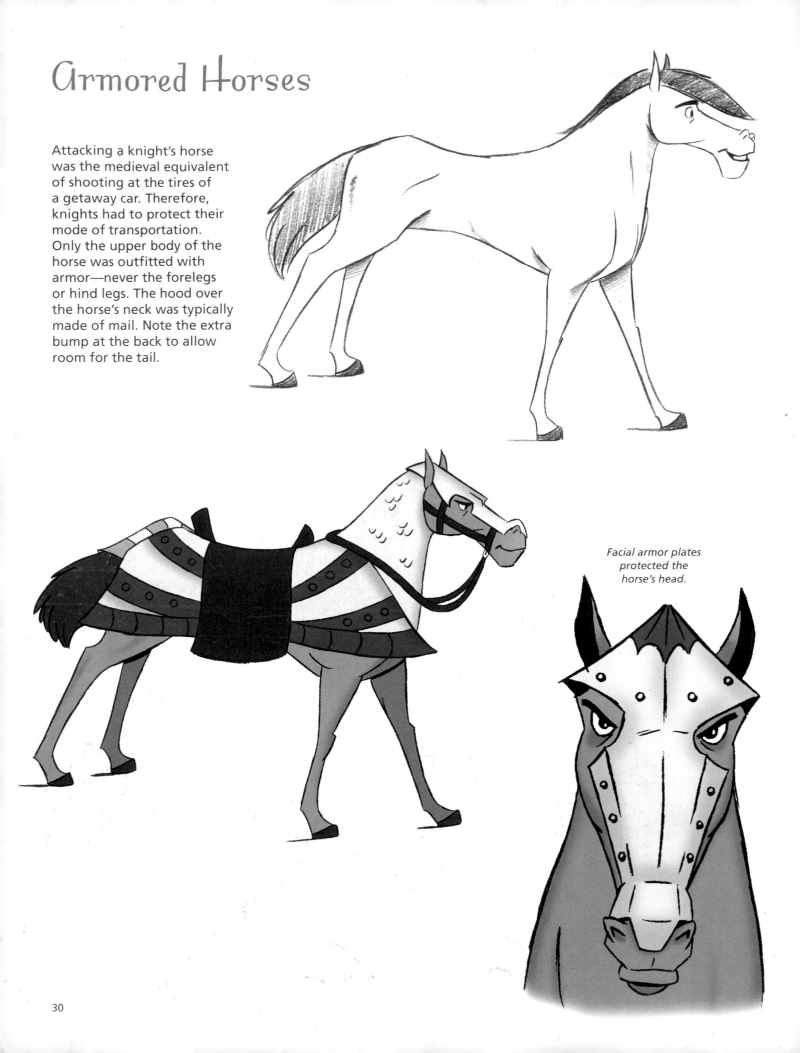

Facial armor plates protected the horse's head.

Cartoony Armored Knight and Steed

In a cartoony pairing of a knight and his steed, the horse is never too thrilled about going along, as a team member, into battle. Not much is needed in the way of armor for the horse; the hood of chain mail is the most important element, as it tends to make the animal look dumb and self-conscious—like a poodle in one of those ridiculous doggy sweaters.

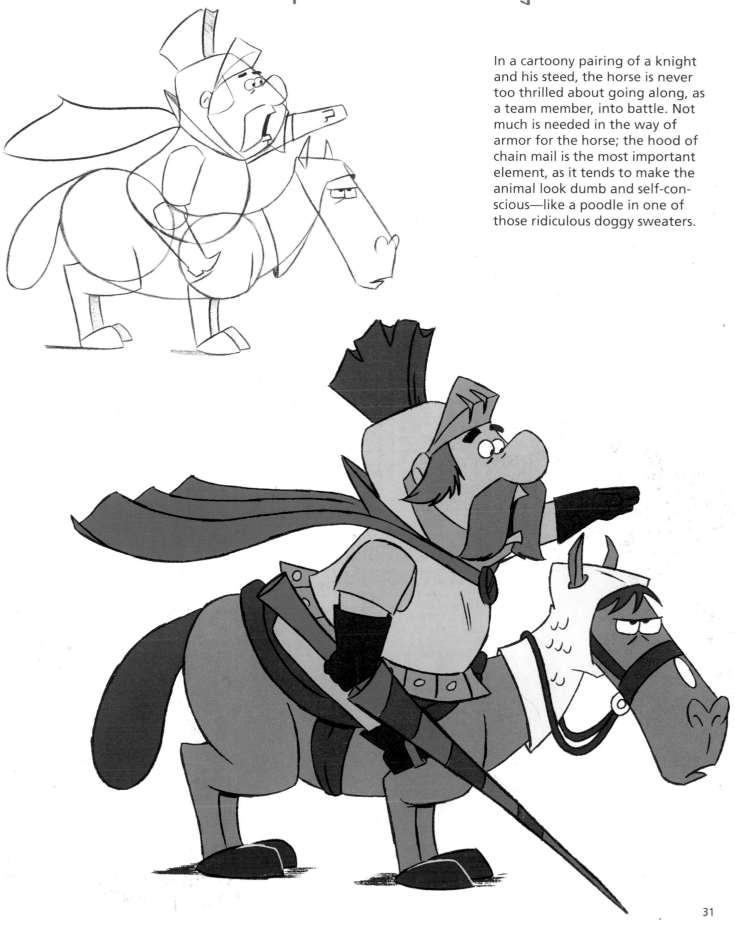

ROYALTY

While a man could earn knighthood (through apprenticeship), he could only be born into royalty. The crown was passed down from father to son. But evil, power-hungry relatives were always scheming to assassinate anyone who stood in the way of their attempts to usurp the throne.

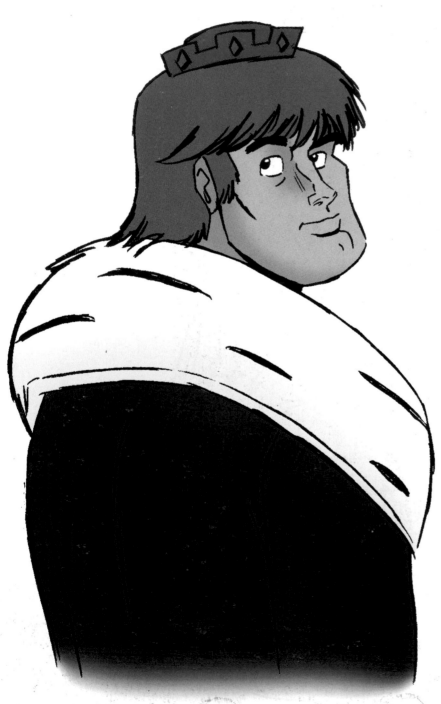

King Arthur: The Classic King

King Arthur was portrayed at many different times in his life, among them: as a boy drawing the sword from the stone to become the rightful king of Britain (see page four of this book); as a young king (left); at his marriage; in victorious battle; and on quests for the Holy Grail. As he grew older, he was shown with facial hair to indicate the passage of time (opposite).

King Arthur is one of the most enduring literary characters of all time. Many credible historians have suggested that there may actually have been a real King Arthur, but if so, he would have existed in a much earlier time—the 6th century and before flashy armor—than he is usually depicted (the 1300s or 1400s). He was kind and noble, courageous and passionate but perhaps too trusting—he was easily betrayed by his closest friend (Sir Lancelot), his wife (Guinevere), his half sister (Morgan Le Fay), and his son (Mordred).

The popular version of the legend tells that King Arthur was killed in battle by his son Mordred, who also perished in the fight. Arthur died just after the prime of his life, so while he is portrayed as no longer having his youth, he did not grow very old.

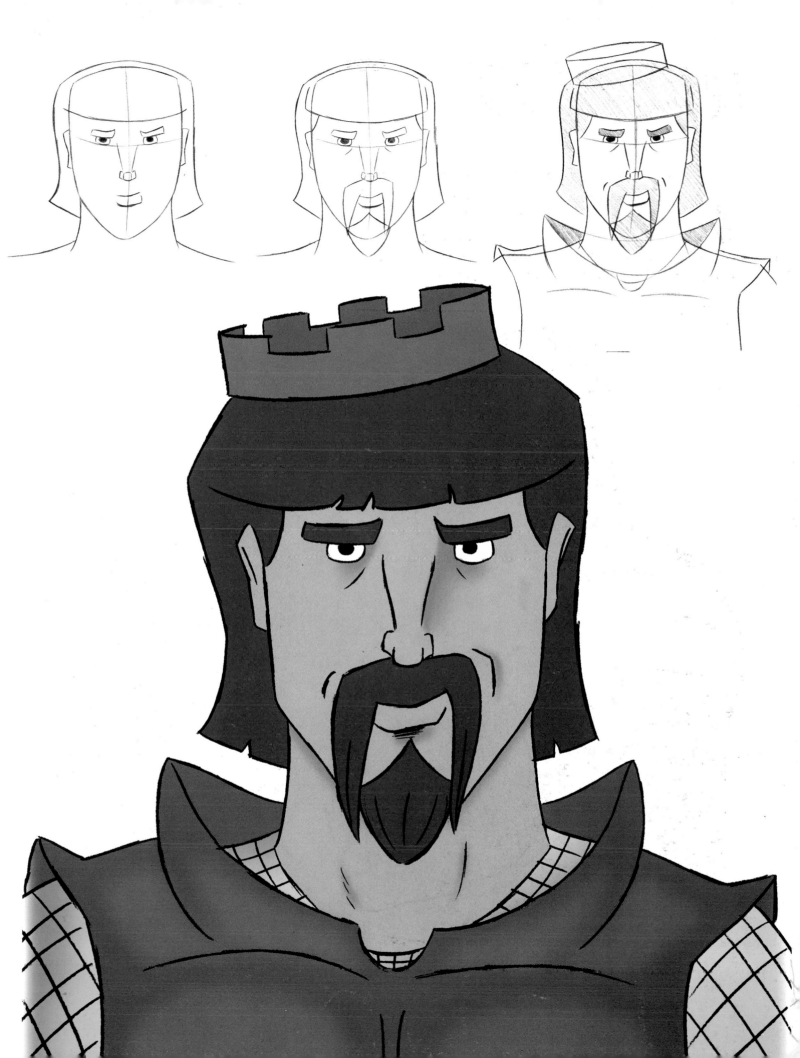

Jolly King

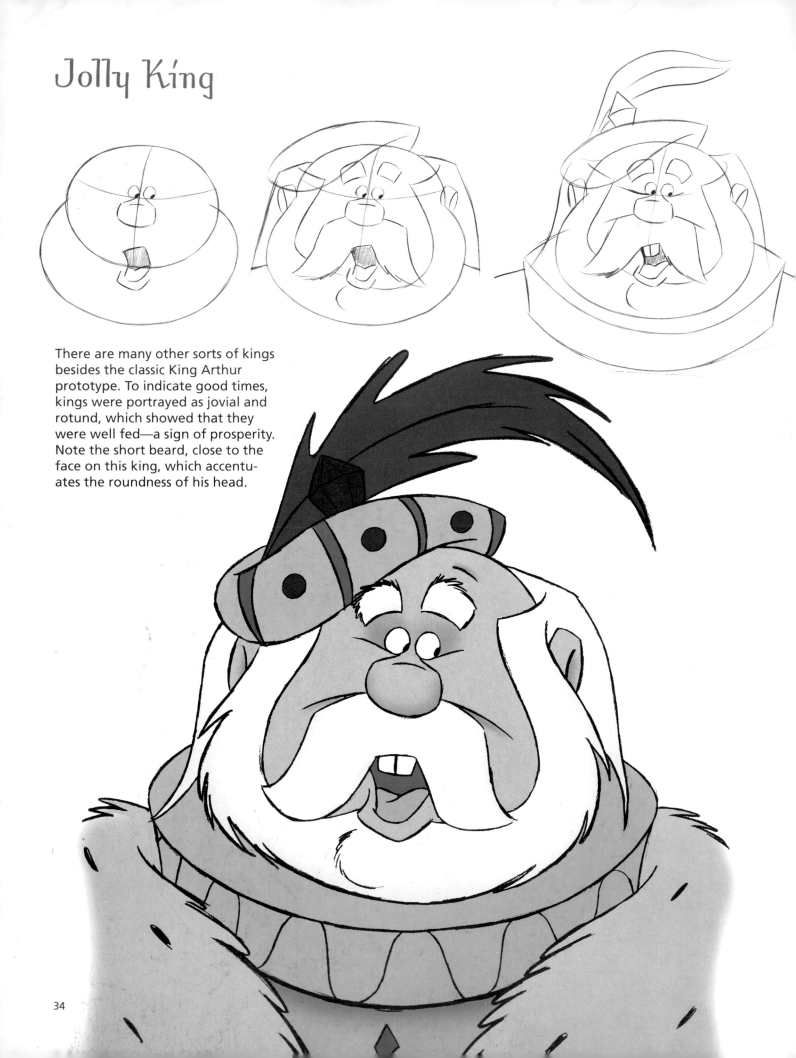

There are many other sorts of kings besides the classic King Arthur prototype. To indicate good times, kings were portrayed as jovial and rotund, which showed that they were well fed—a sign of prosperity. Note the short beard, close to the face on this king, which accentuates the roundness of his head.

Kind (but Stupid) King

One common representation of a monarch is that of the kind but stupid king, who is easily manipulated by his wicked advisers. Focus on the sleepy eyes with heavy eyelids.

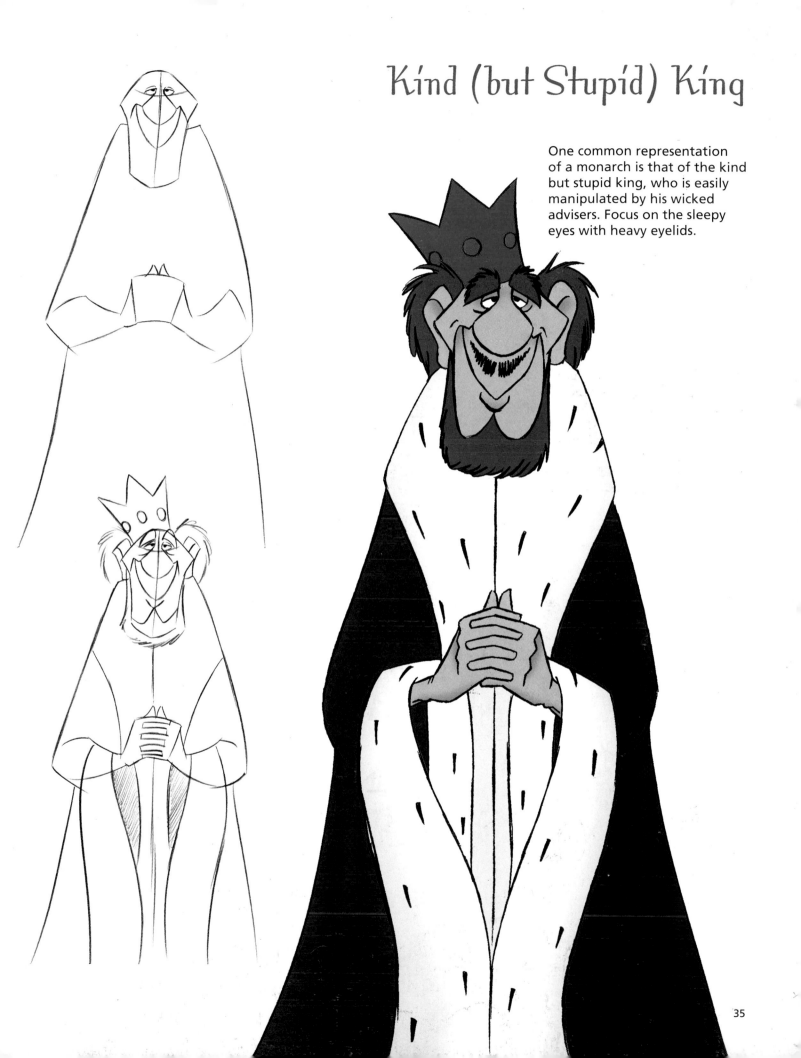

Old Warrior King

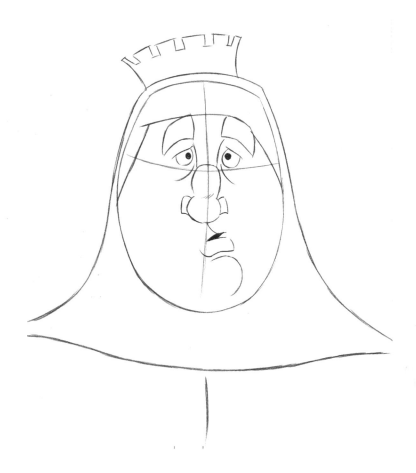

During medieval times, all kings were knights as well. If the castle fell under siege, they could still fight if necessary. Mail worn over the head is indicative of this type of king.

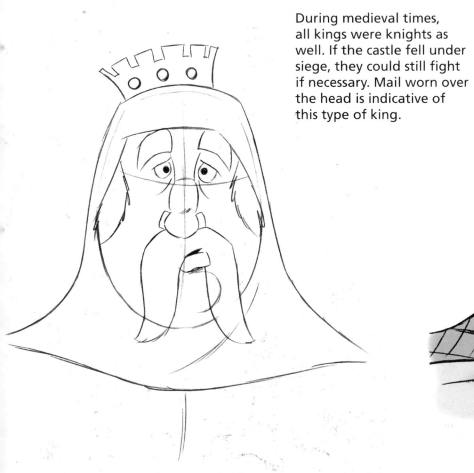

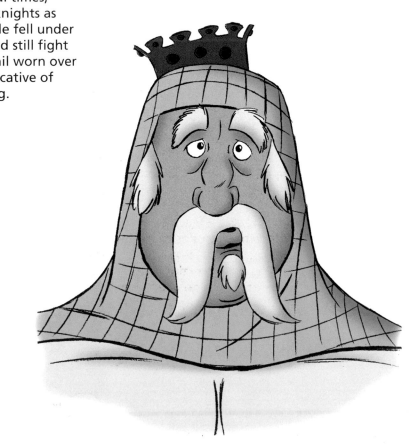

Unready King

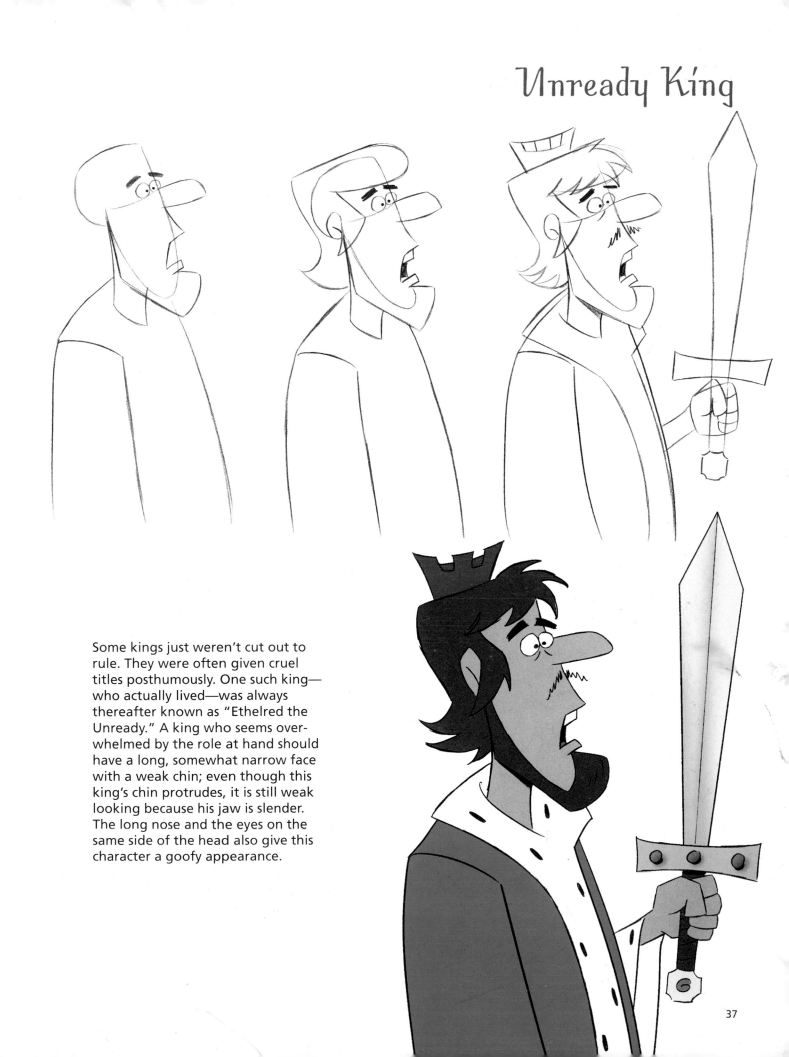

Some kings just weren't cut out to rule. They were often given cruel titles posthumously. One such king—who actually lived—was always thereafter known as "Ethelred the Unready." A king who seems overwhelmed by the role at hand should have a long, somewhat narrow face with a weak chin; even though this king's chin protrudes, it is still weak looking because his jaw is slender. The long nose and the eyes on the same side of the head also give this character a goofy appearance.

Forgetful King

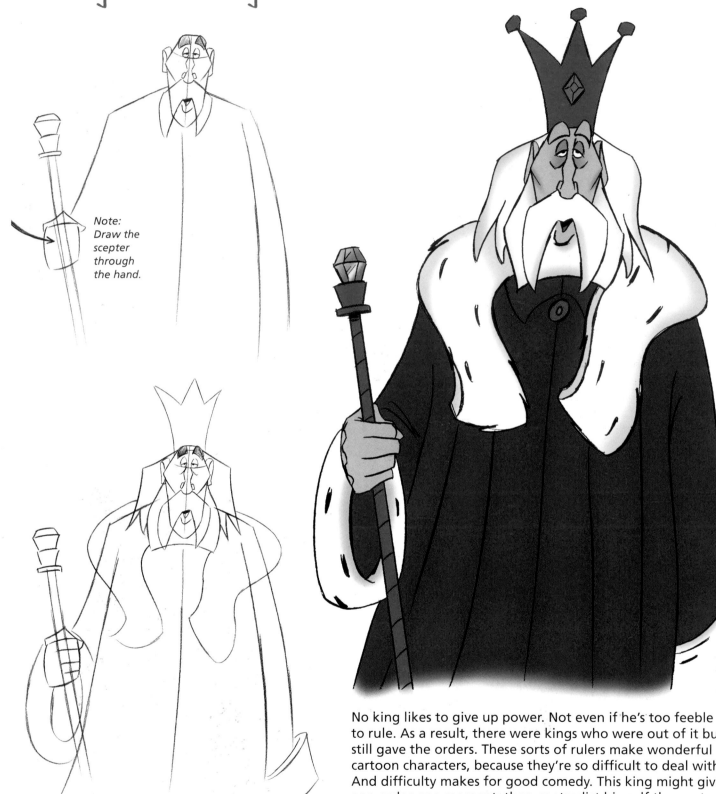

Note: Draw the scepter through the hand.

No king likes to give up power. Not even if he's too feeble to rule. As a result, there were kings who were out of it but still gave the orders. These sorts of rulers make wonderful cartoon characters, because they're so difficult to deal with. And difficulty makes for good comedy. This king might give one order one moment, then contradict himself the next. Note the placid look on his face, as if nothing is quite getting through to him. The older and more forgetful he becomes, the more lavish his costume and ornaments should be—as if he's holding onto his power through pageantry, rather than by the force of his personality and capability.

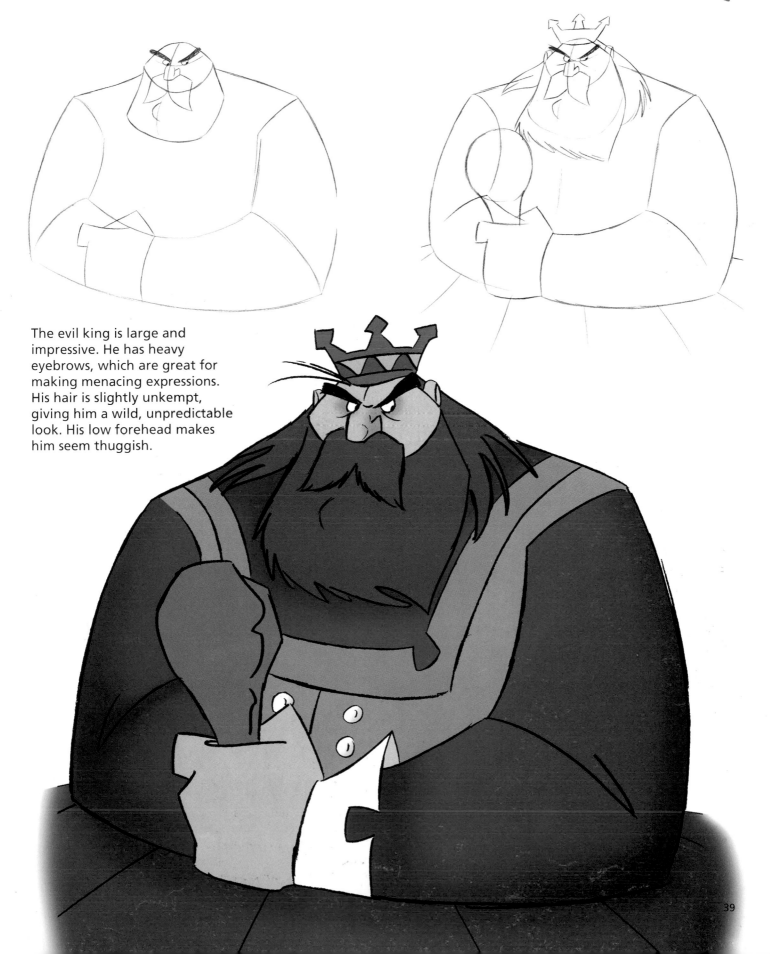

The evil king is large and impressive. He has heavy eyebrows, which are great for making menacing expressions. His hair is slightly unkempt, giving him a wild, unpredictable look. His low forehead makes him seem thuggish.

Classic Queen

Nothing so moves a knight as a smile from a beautiful queen. This type of beauty is not the glamorous kind but the unassuming beauty that radiates from within. Softer angles are the hallmark of this sort of female head. The chin narrows but never comes to a complete point. The neck is thin and supple. The focus of the face is the large eyes, each highlighted by a single, dark line that doubles as eyelid and eyelashes. Draw the nose lightly, and make sure the lips are full.

Note that there are as many different types of queens as there are personalities; you can use these basic drawing guidelines to create any sort of queen.

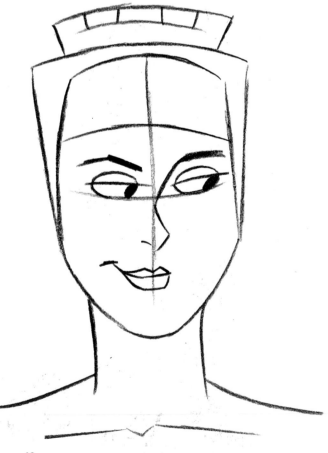

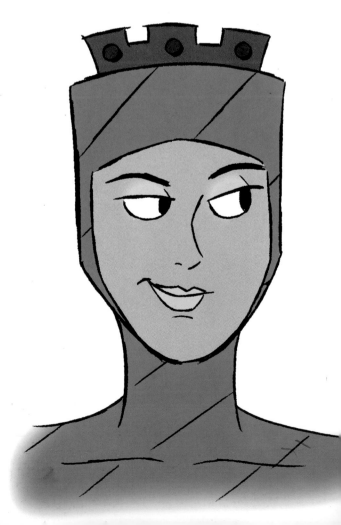

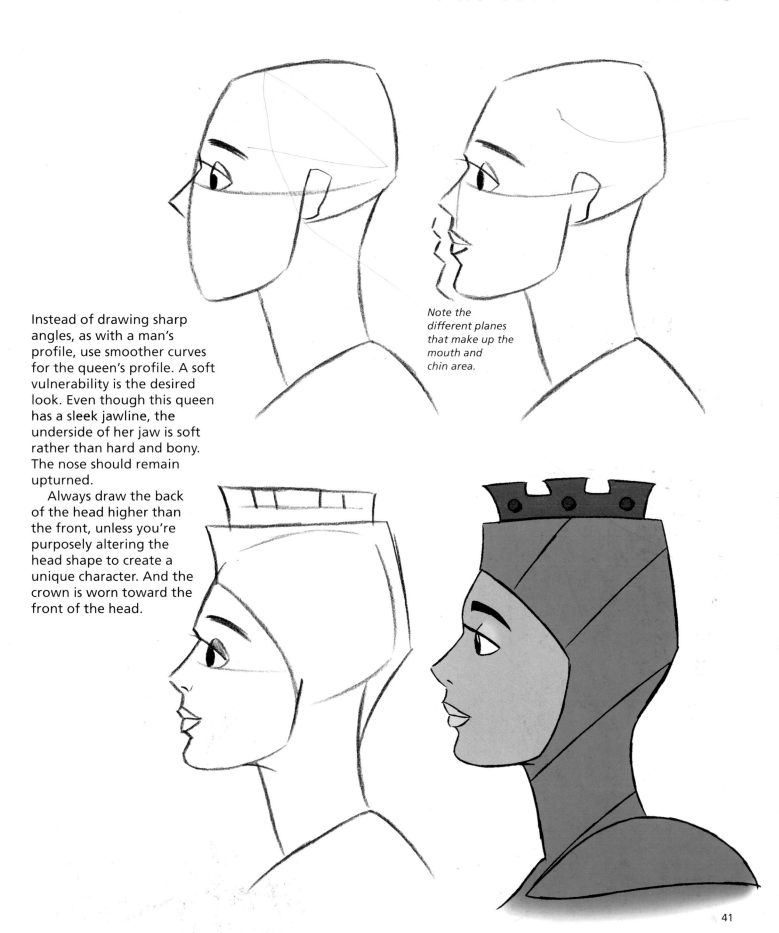

Note the different planes that make up the mouth and chin area.

Instead of drawing sharp angles, as with a man's profile, use smoother curves for the queen's profile. A soft vulnerability is the desired look. Even though this queen has a sleek jawline, the underside of her jaw is soft rather than hard and bony. The nose should remain upturned.

Always draw the back of the head higher than the front, unless you're purposely altering the head shape to create a unique character. And the crown is worn toward the front of the head.

The Queen's Figure

When drawing the full figure, concentrate on the major masses of the body: the rib cage and the pelvis. The waist is narrow, and the hips are wide. The shoulders are square but not muscular. The trapezius muscle (which connects the neck to the shoulders) is very slight on a woman. In the side view, some of the mass of the back is visible behind the shoulders.

When creating long, flowing dresses, it's tempting to draw the costume without first mapping out where the pelvis and legs go. This is usually a bad idea. Start by drawing the underlying figure as a foundation so that the waistline will fit more snugly into the hips, and most importantly, the length of the legs will be correct in relation to the body.

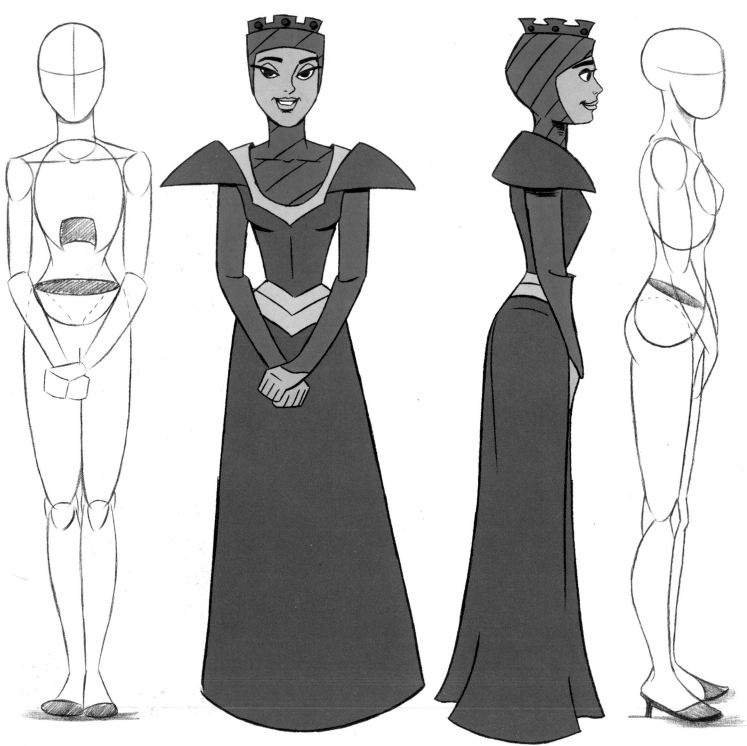

Queens Enthroned

The throne is the seat of power—literally. It elevates a queen above her subjects. Thrones were carved out of wood, and although they had some upholstery, they were not cozy chairs that you'd curl up in with a good book. An evil scheme seems that much more wicked if it is hatched while the queen is on her throne.

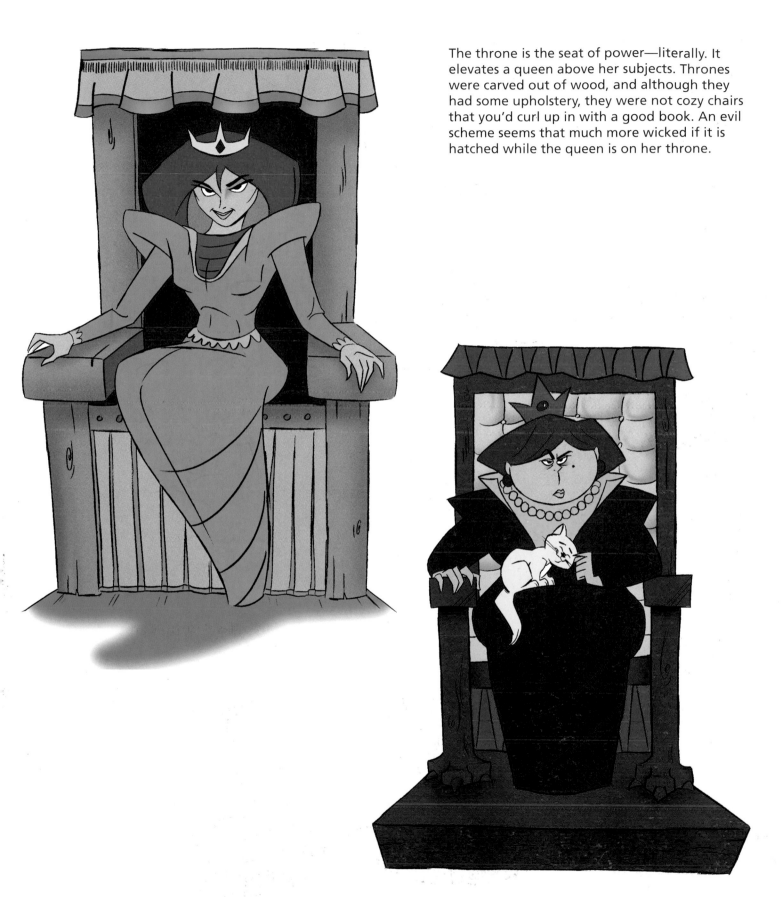

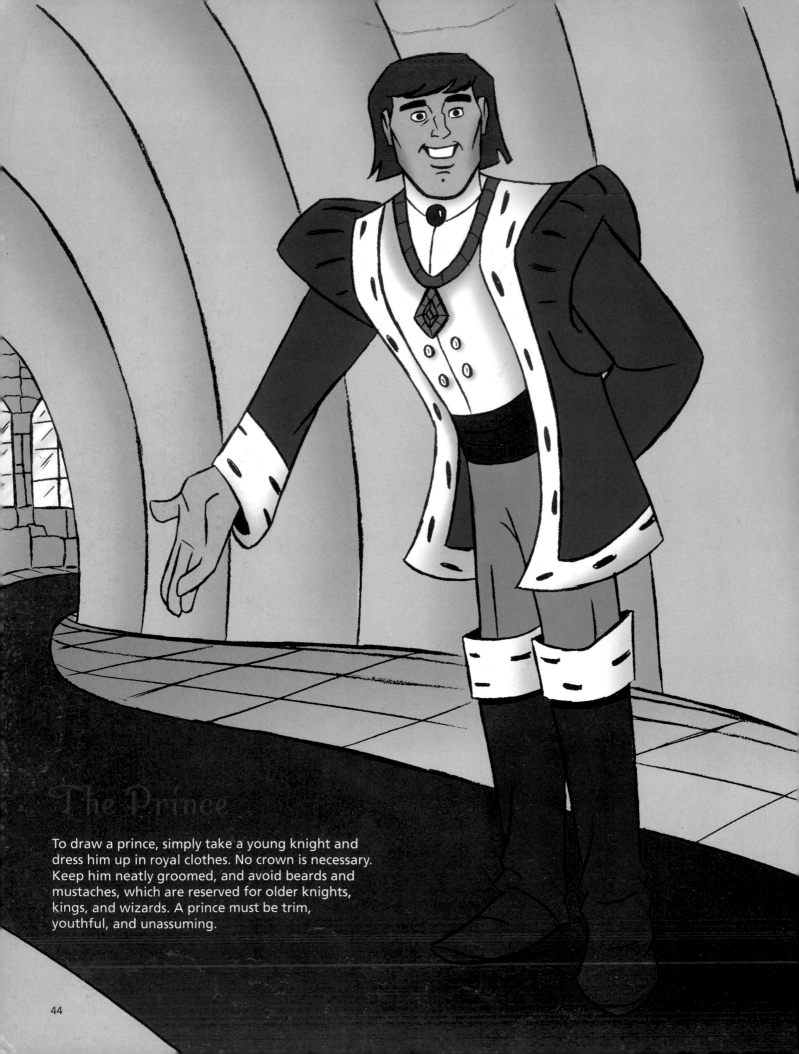

The Prince

To draw a prince, simply take a young knight and dress him up in royal clothes. No crown is necessary. Keep him neatly groomed, and avoid beards and mustaches, which are reserved for older knights, kings, and wizards. A prince must be trim, youthful, and unassuming.

Princesses don't have to wear crowns all the time, as do queens. This hat-and-veil combination was also extremely common. The hairstyle on this princess was trendy back in the 1400s. Draw the hair parted straight down the middle, and place two buns wrapped in tight ovals over the ears.

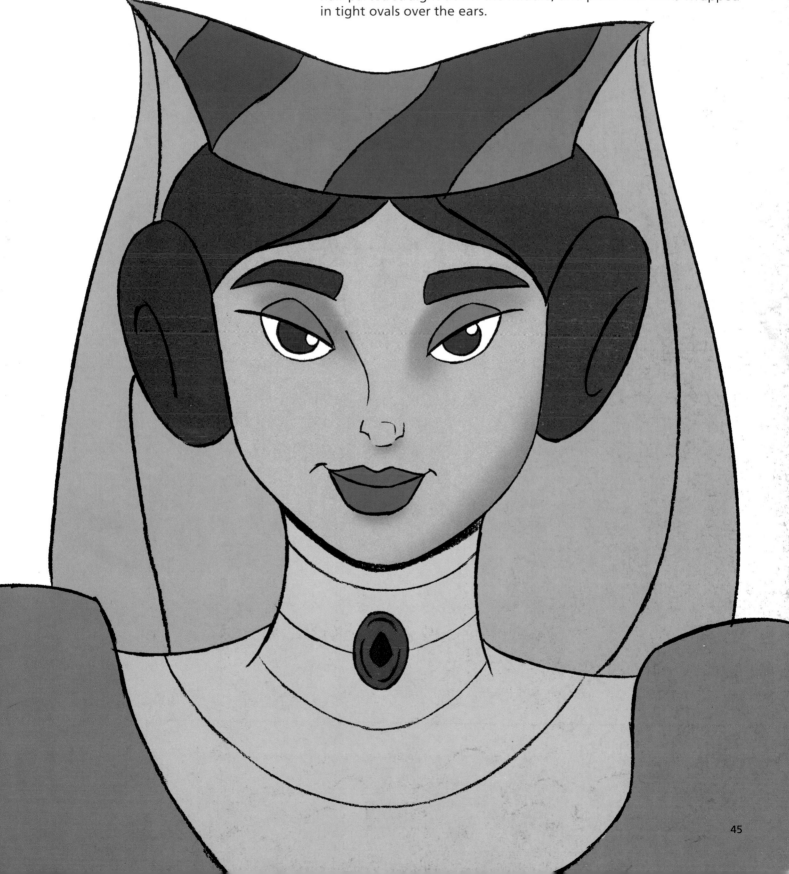

Princess from a Lesser Kingdom

The word *castle* brings to mind images of majestic dwellings, but in truth, there were many smaller castles that dotted the countryside. Not all kingdoms were filthy rich; some kings only ruled over the equivalent of a small town. Accordingly, a princess from a modest kingdom would be more likely to go for barefoot strolls in the forest and be less formal in appearance; she'd have long, flowing hair and wear looser-fitting garments.

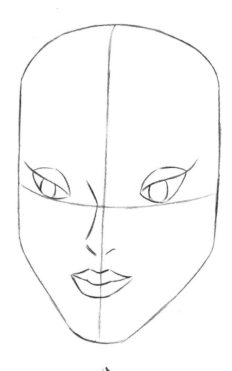

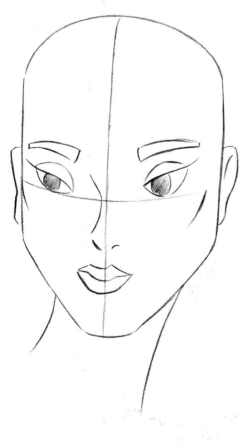

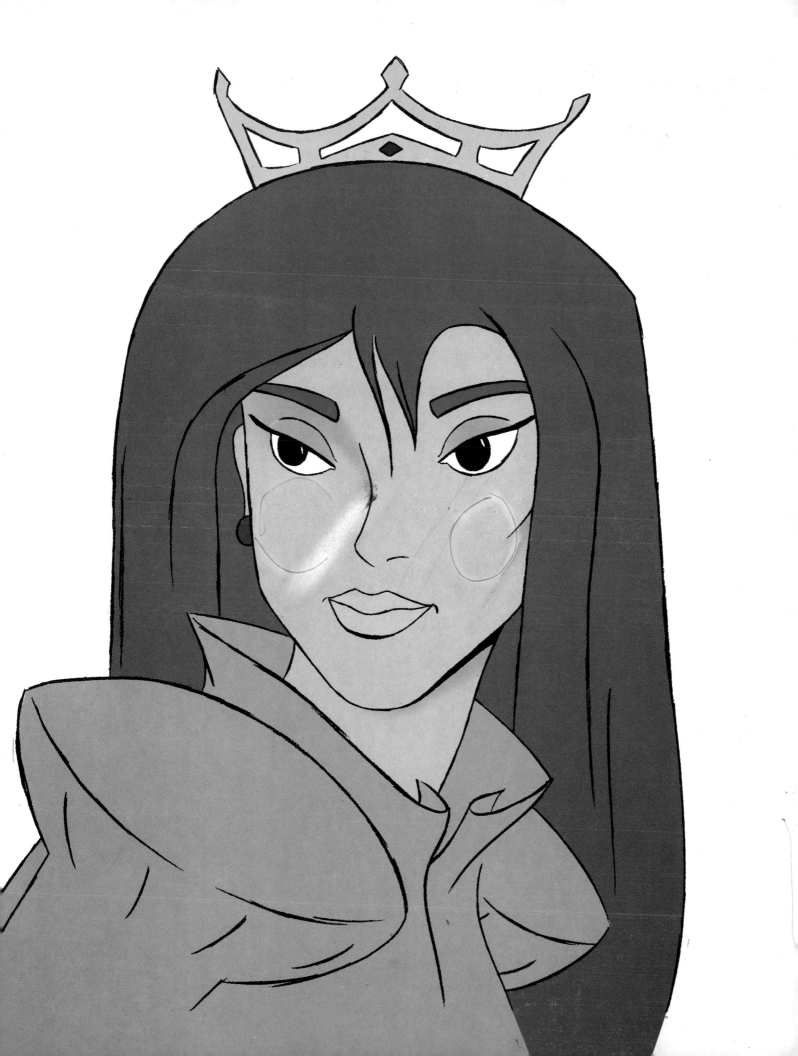

The Princess as a Little Girl

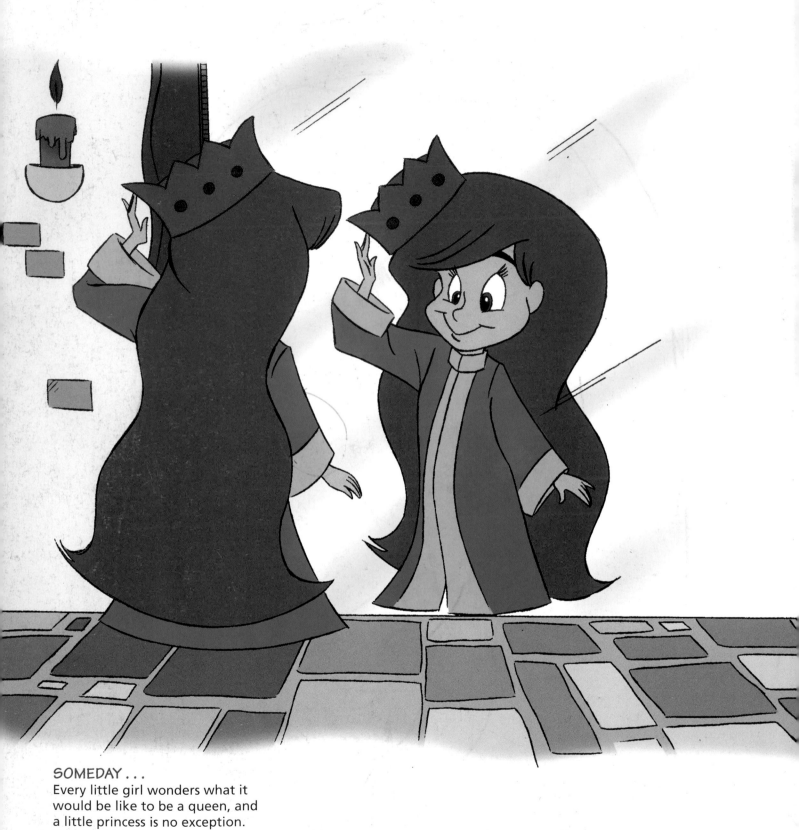

SOMEDAY . . .
Every little girl wonders what it would be like to be a queen, and a little princess is no exception. When a little princess secretly tries on her mother's crown, the crown must be oversized.

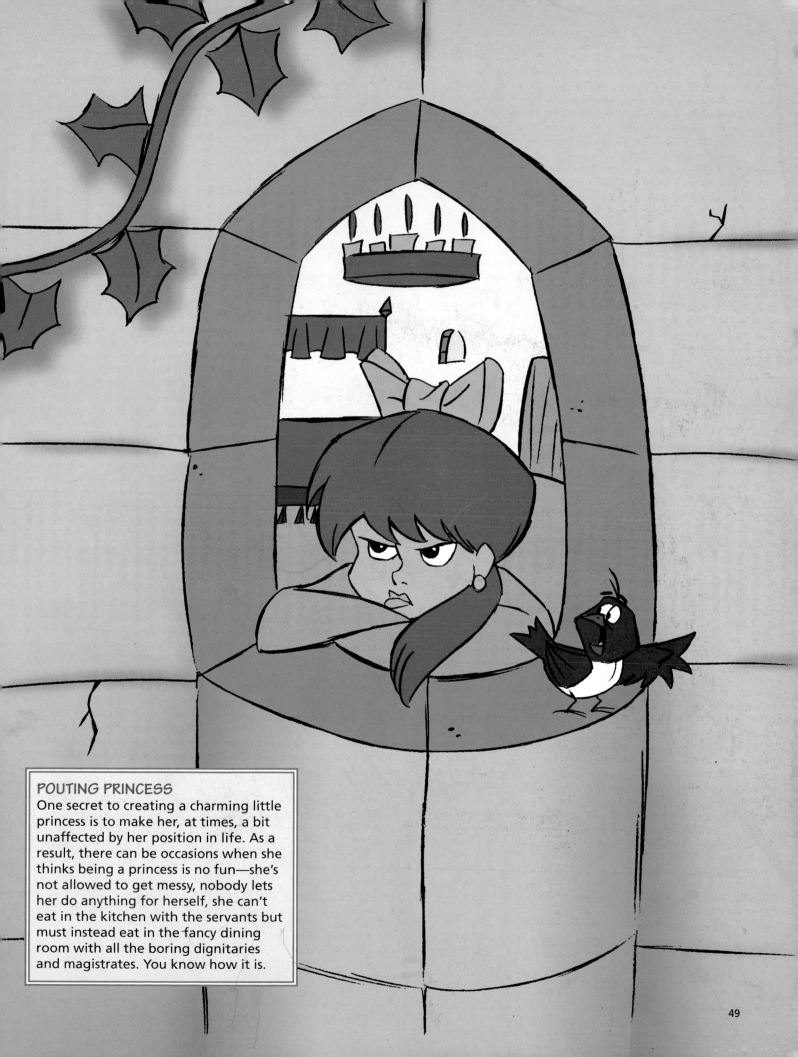

POUTING PRINCESS
One secret to creating a charming little princess is to make her, at times, a bit unaffected by her position in life. As a result, there can be occasions when she thinks being a princess is no fun—she's not allowed to get messy, nobody lets her do anything for herself, she can't eat in the kitchen with the servants but must instead eat in the fancy dining room with all the boring dignitaries and magistrates. You know how it is.

AROUND THE KINGDOM

Now let's take a tour of a typical medieval village, see all the goings-on, and sneak a peek behind the scenes.

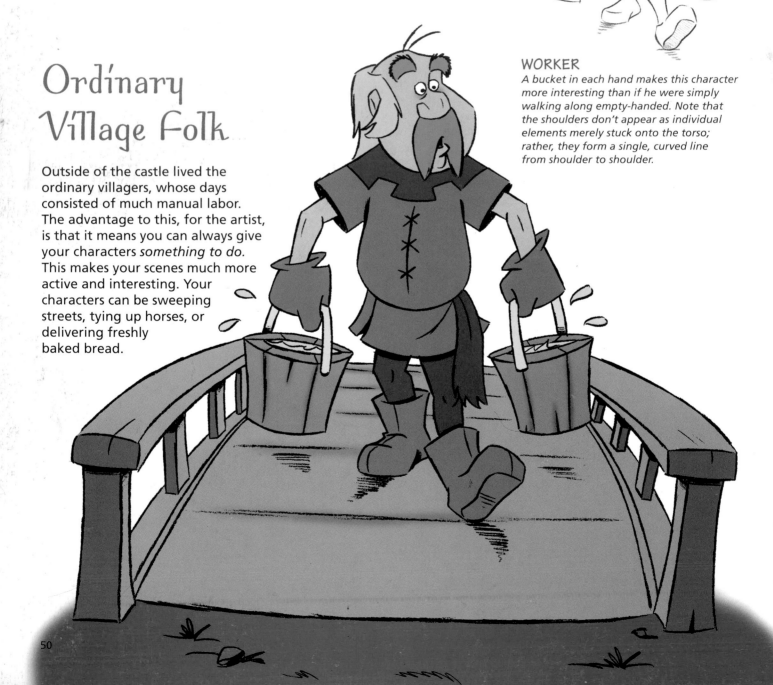

Ordinary Village Folk

Outside of the castle lived the ordinary villagers, whose days consisted of much manual labor. The advantage to this, for the artist, is that it means you can always give your characters *something to do*. This makes your scenes much more active and interesting. Your characters can be sweeping streets, tying up horses, or delivering freshly baked bread.

WORKER
A bucket in each hand makes this character more interesting than if he were simply walking along empty-handed. Note that the shoulders don't appear as individual elements merely stuck onto the torso; rather, they form a single, curved line from shoulder to shoulder.

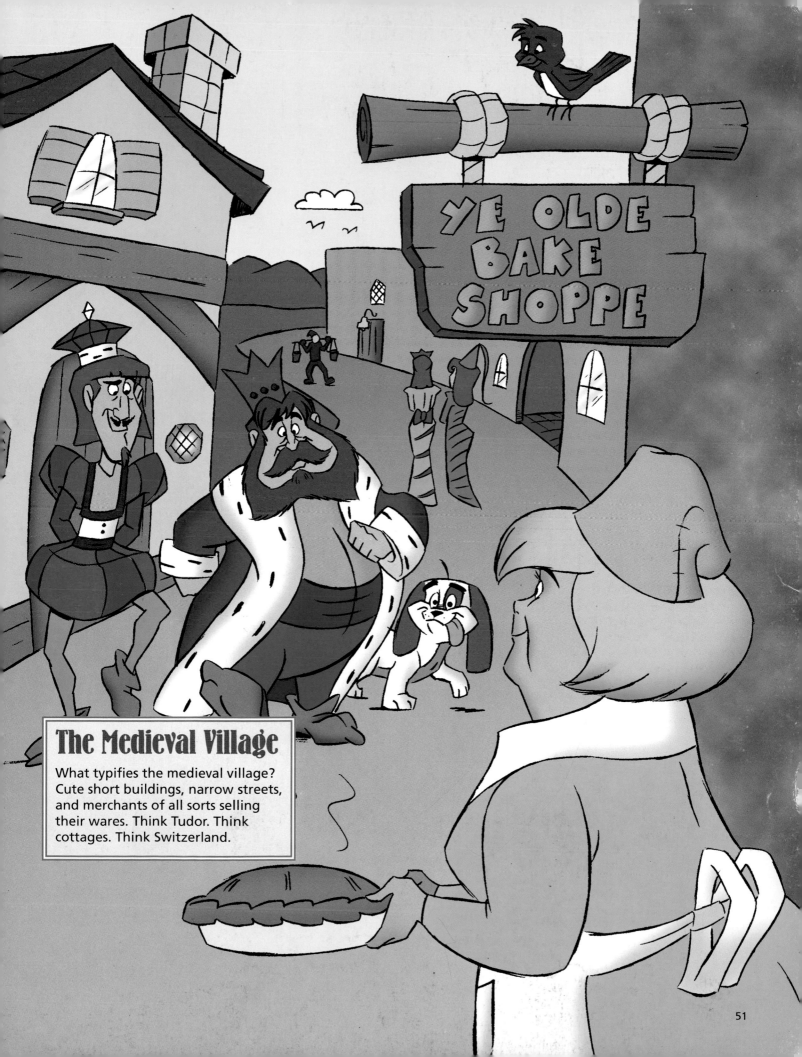

The Medieval Village

What typifies the medieval village? Cute short buildings, narrow streets, and merchants of all sorts selling their wares. Think Tudor. Think cottages. Think Switzerland.

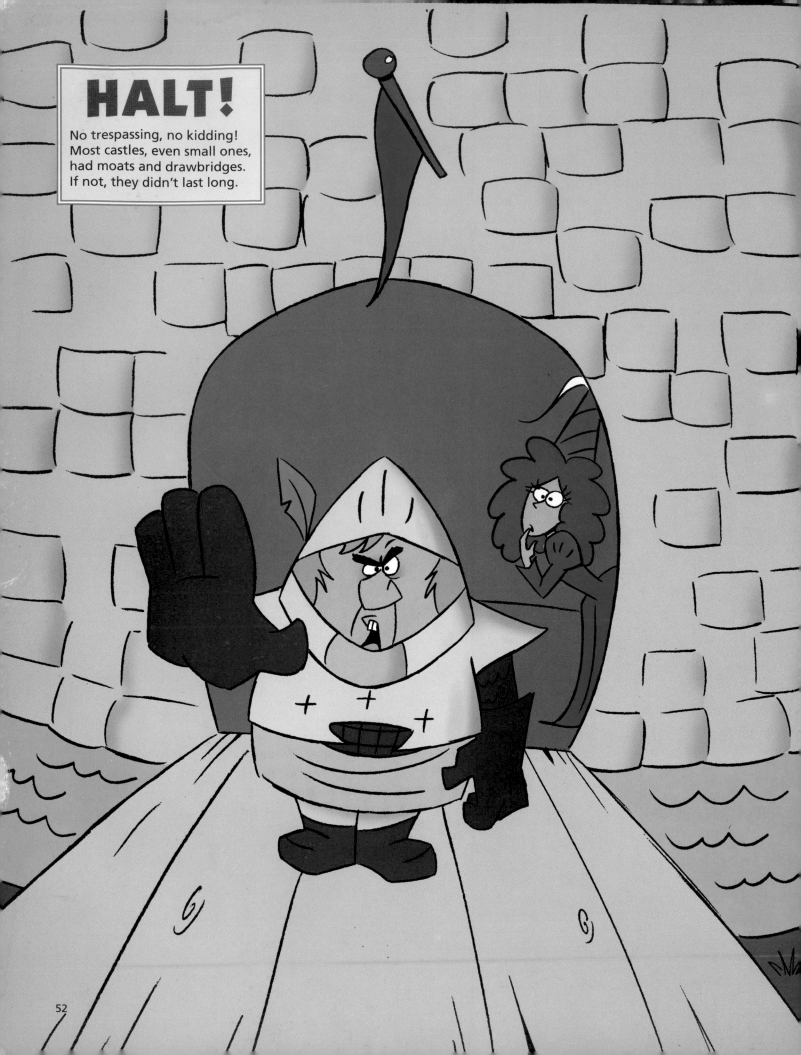

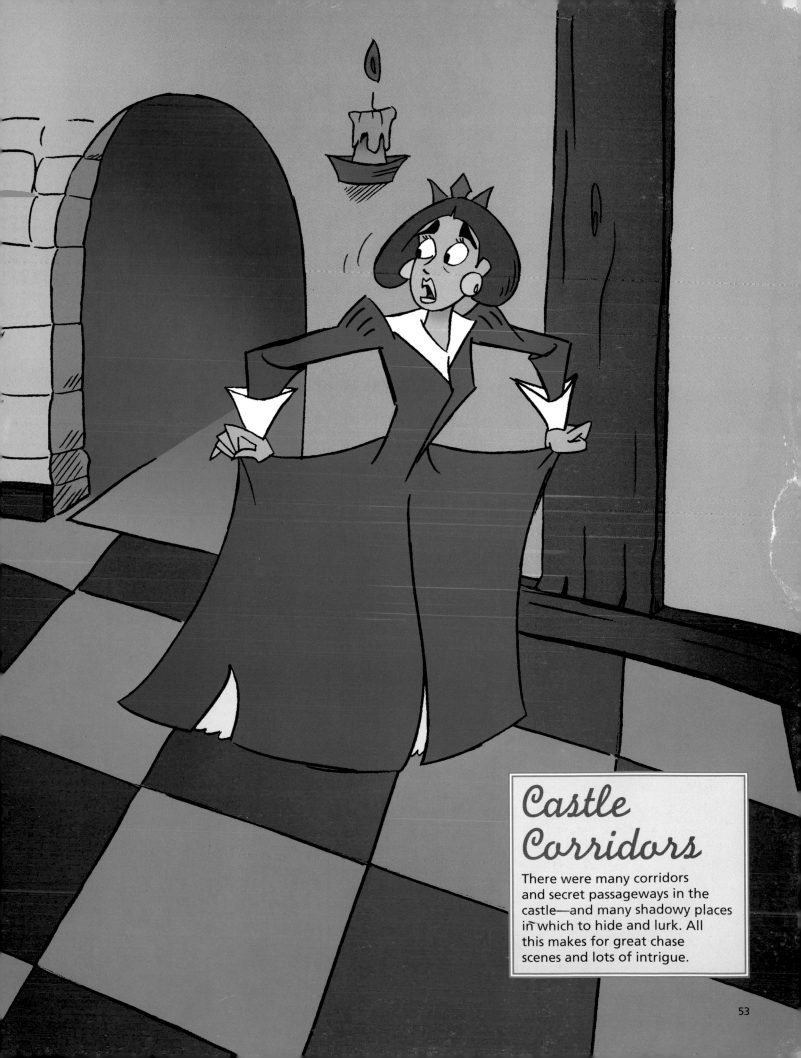

Castle Corridors

There were many corridors and secret passageways in the castle—and many shadowy places in which to hide and lurk. All this makes for great chase scenes and lots of intrigue.

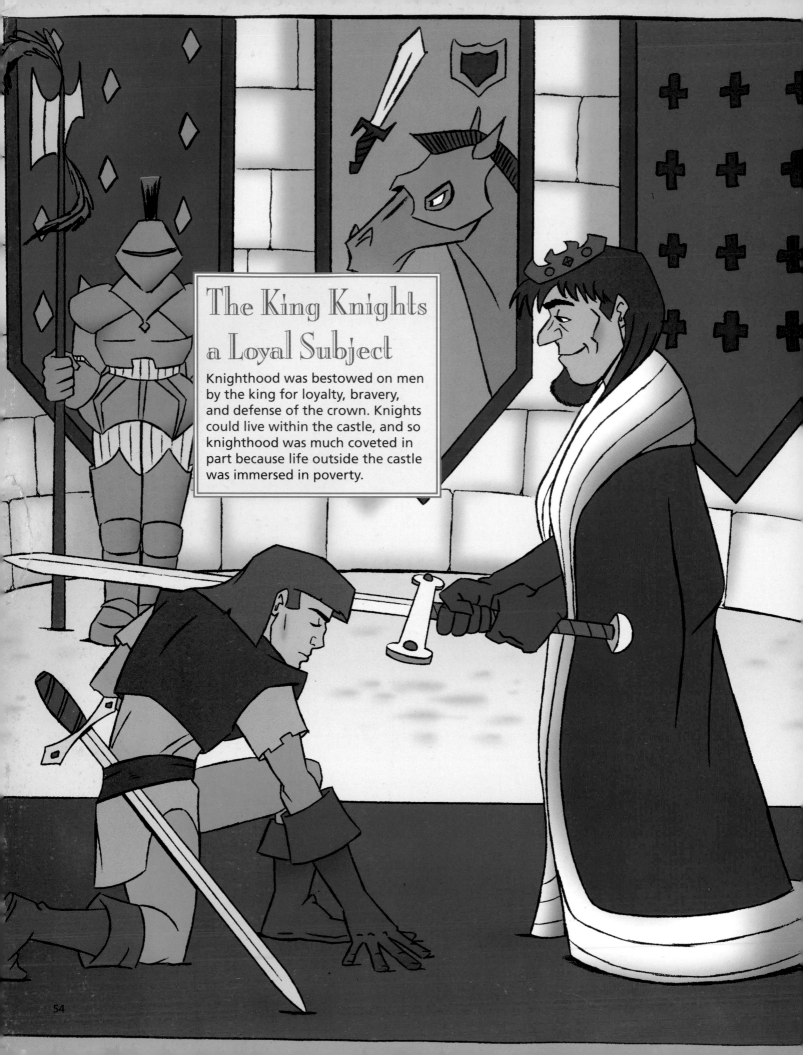

The King Knights a Loyal Subject

Knighthood was bestowed on men by the king for loyalty, bravery, and defense of the crown. Knights could live within the castle, and so knighthood was much coveted in part because life outside the castle was immersed in poverty.

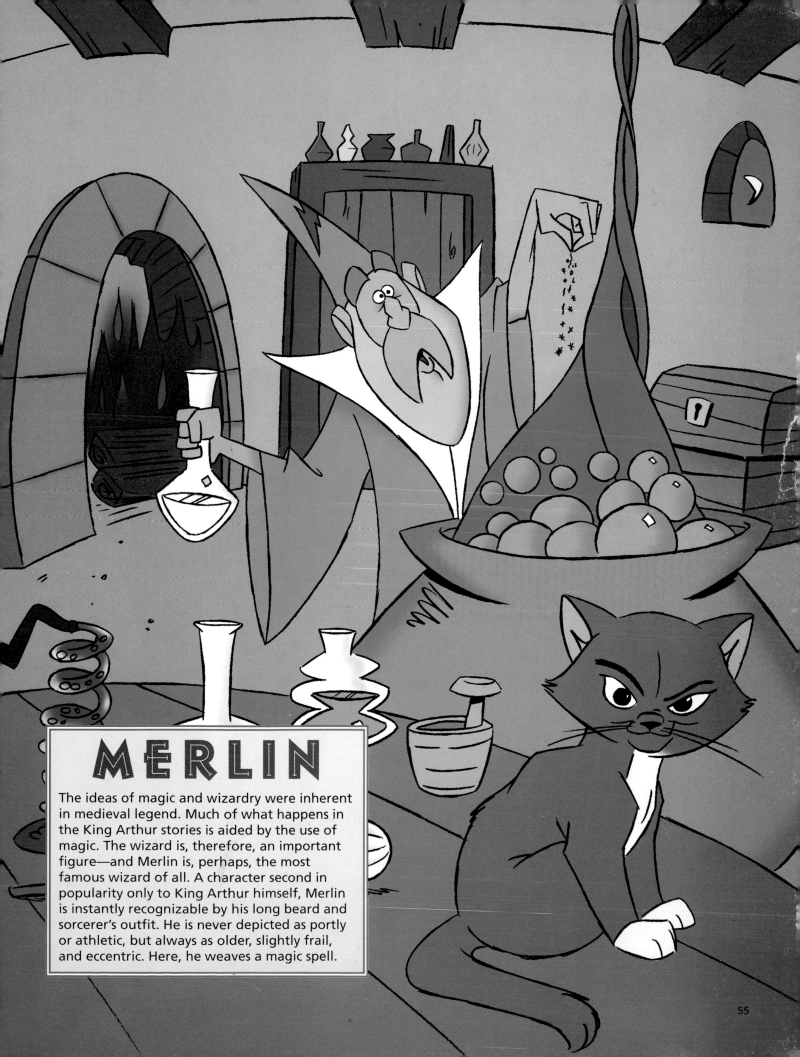

MERLIN

The ideas of magic and wizardry were inherent in medieval legend. Much of what happens in the King Arthur stories is aided by the use of magic. The wizard is, therefore, an important figure—and Merlin is, perhaps, the most famous wizard of all. A character second in popularity only to King Arthur himself, Merlin is instantly recognizable by his long beard and sorcerer's outfit. He is never depicted as portly or athletic, but always as older, slightly frail, and eccentric. Here, he weaves a magic spell.

MERLIN'S STUDY

At a time when getting a proper education meant learning how to swing a sword, only a few characters had the ability to read. Merlin was one such figure. To create many of his potions and spells, he would refer to his book of incantations. Reading by candlelight adds to the magical quality of this type of scene.

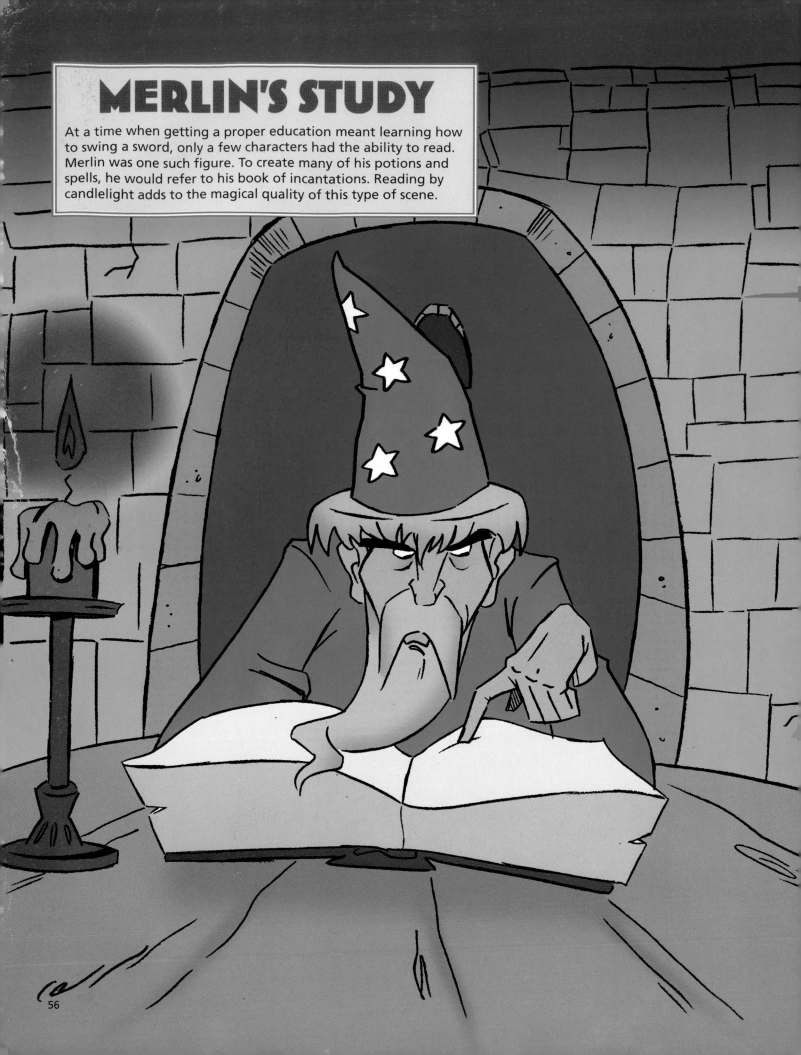

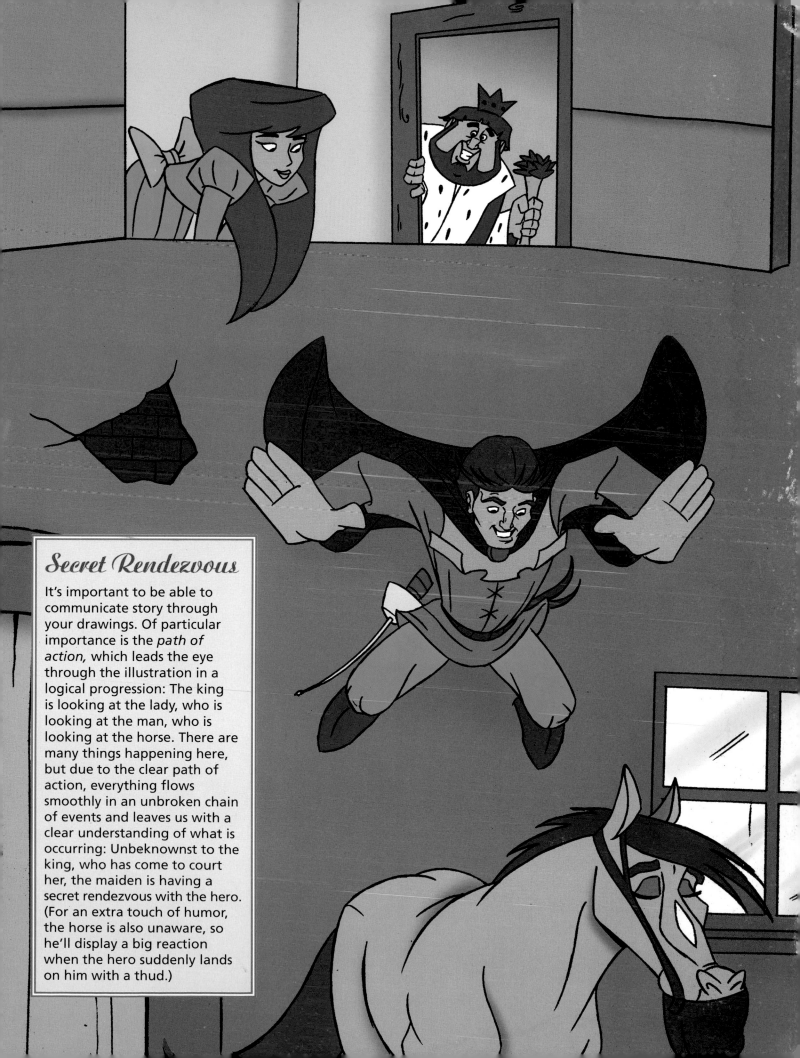

Secret Rendezvous

It's important to be able to communicate story through your drawings. Of particular importance is the *path of action,* which leads the eye through the illustration in a logical progression: The king is looking at the lady, who is looking at the man, who is looking at the horse. There are many things happening here, but due to the clear path of action, everything flows smoothly in an unbroken chain of events and leaves us with a clear understanding of what is occurring: Unbeknownst to the king, who has come to court her, the maiden is having a secret rendezvous with the hero. (For an extra touch of humor, the horse is also unaware, so he'll display a big reaction when the hero suddenly lands on him with a thud.)

DRAGONS

If there is one ultimate medieval enemy, the dragon must be it. There can be no clearer battle between good and evil than when a knight stands his ground to confront this dark creature. In addition to having all he can handle in the dragon, the knight must sometimes battle his own horse, which would rather turn tail and run.

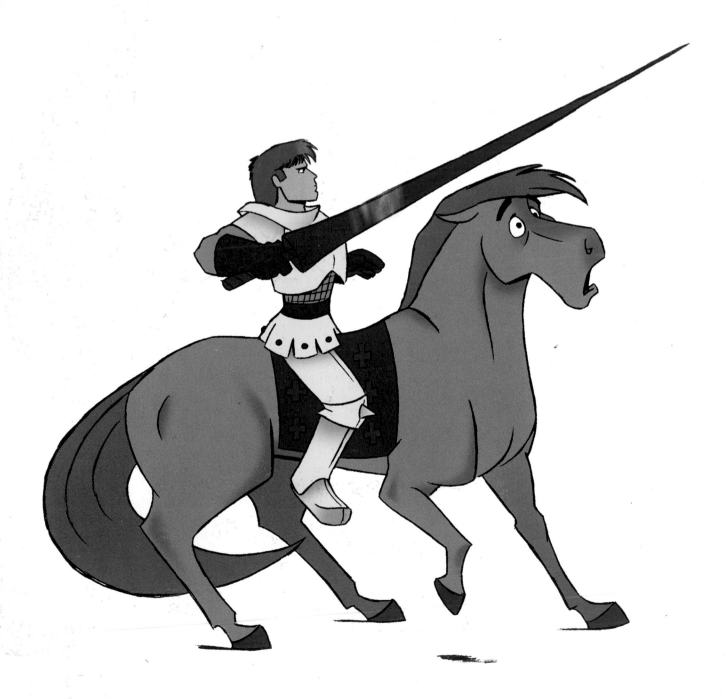

Classic Dragon

Dragons can be drawn in many different ways, with or without wings, and with various types of horns. They can be evil, sly, or even funny. They can be green, blue, red, gray, or yellow. But, they always have dorsal plates and long tails, and they are always derived from reptiles.

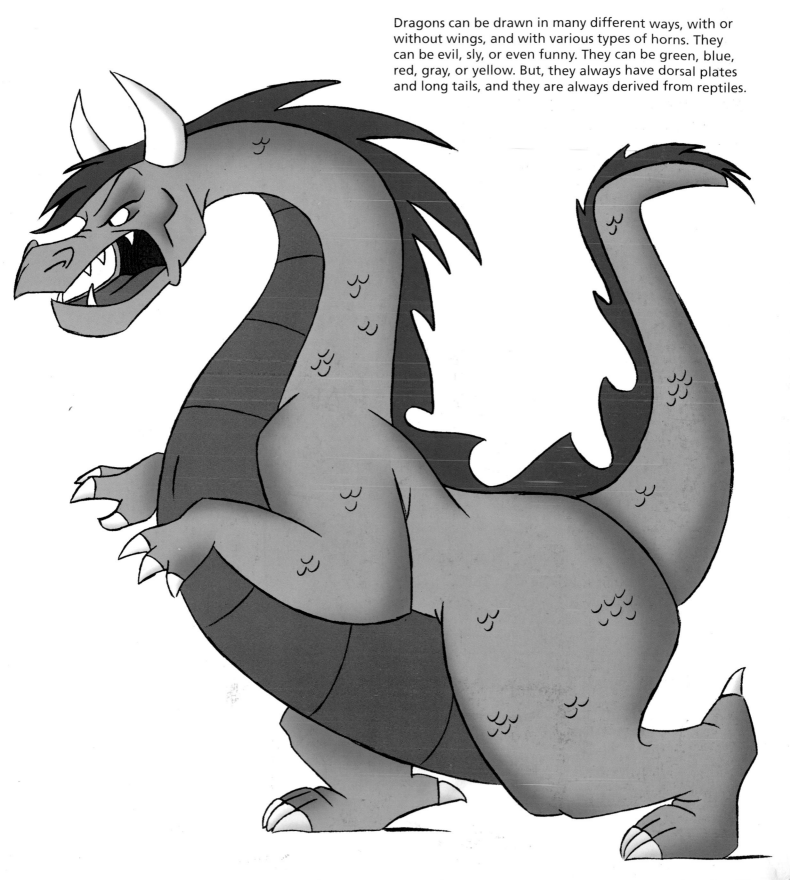

The Dragon's Head

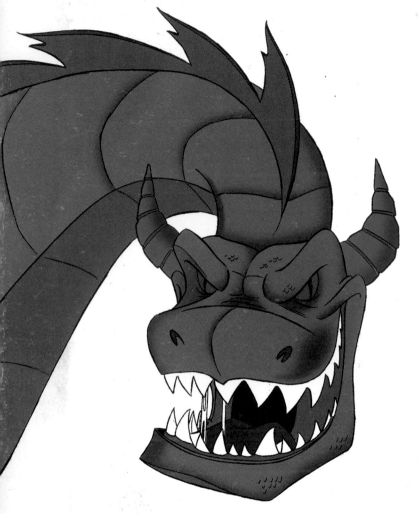

HEAD CONSTRUCTION

A dragon's head is a combination of a horse head and a crocodile head. (Note that crocodiles have pointy snouts; alligators have wide ones.) The forehead of a dragon looks more like that of a horse, but the nose of a dragon looks more like that of a crocodile. The bottom jaw is a combination of both.

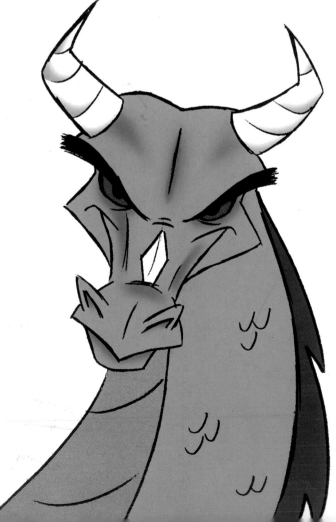

ASIAN STYLE VS. WESTERN STYLE

The Asian-style dragon (above) typically has a boxier head shape than its western-style counterpart (right). It is also even more fearsome than its western cousin, with snakelike eyes and razor teeth giving it a wild, vicious look. Note the slits for the pupils, too. However, although it makes an impressive villain, the Asian-style dragon is often not good for conveying a variety of expressions (due to its predominantly evil look) and, therefore, serves only as a one-dimensional character.

Silly Dragon

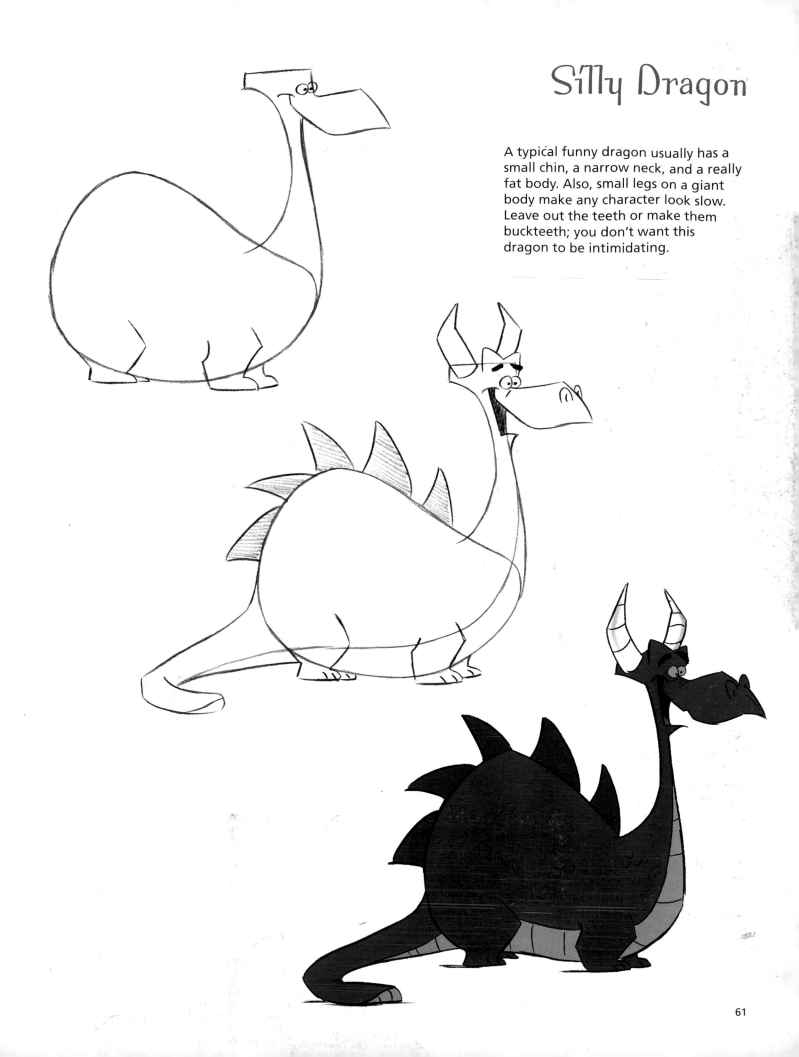

A typical funny dragon usually has a small chin, a narrow neck, and a really fat body. Also, small legs on a giant body make any character look slow. Leave out the teeth or make them buckteeth; you don't want this dragon to be intimidating.

Humorous Dragons

Since dragons are entirely a product of the imagination, you can go as far out as you like in inventing your own.

When drawing a humorous dragon, not only can you break with tradition and dress him in modern-day costume, but you can put him in a modern setting. The effect will be hilarious. Don't be afraid to deviate from the norm when creating humorous characters from another era.

MOODY
Some dragons are always cranky.

YOUNG
Everybody loves a baby dragon.

OUT OF SHAPE
Even dragons like sweets.

ATHLETIC
This dragon's a sportsman.

GOOFY
The long tongue and close-set eyes give this dragon a slightly goofy look.

Winged Dragons

A dragon's wings don't always have to be large enough for flight. Here they just serve to add a sense of mystery and otherworldliness to the creature. Note that a dragon doesn't have to be a large, obese creature; it can be athletic looking with a powerful chest and narrow waist. It's the long, thin face and small forehead that give the dragon its evil appearance.

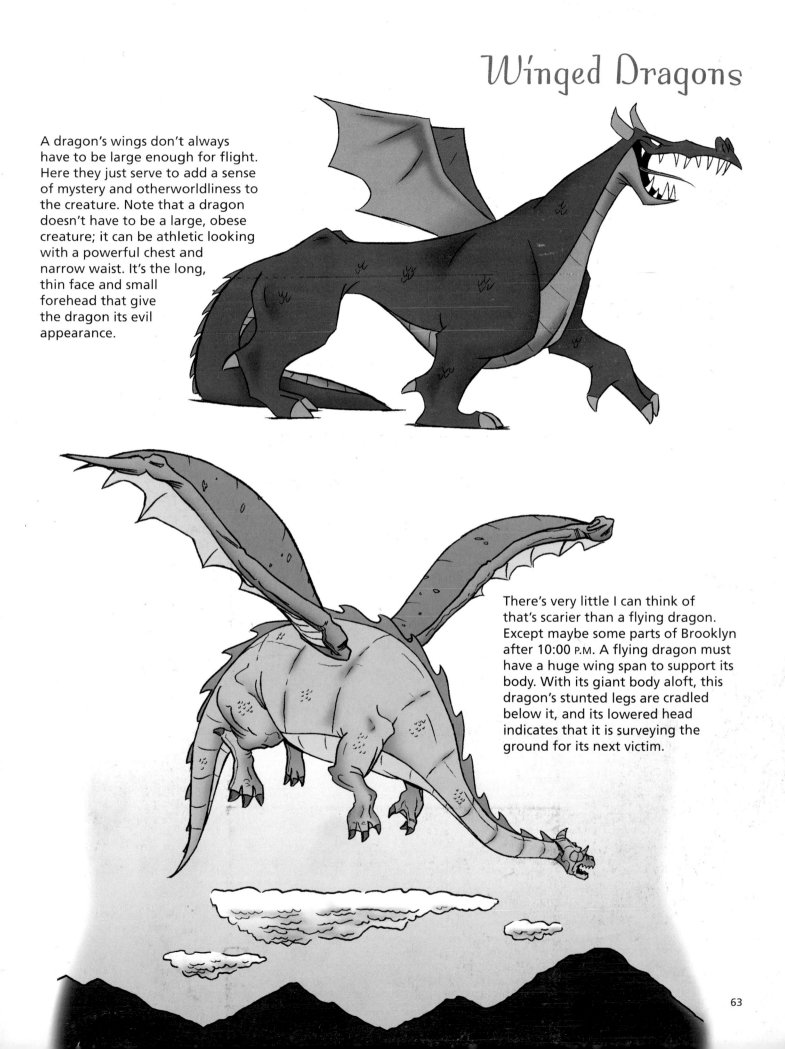

There's very little I can think of that's scarier than a flying dragon. Except maybe some parts of Brooklyn after 10:00 P.M. A flying dragon must have a huge wing span to support its body. With its giant body aloft, this dragon's stunted legs are cradled below it, and its lowered head indicates that it is surveying the ground for its next victim.

INDEX